GRANDMA MOSES: GRANDMOTHER TO THE NATION

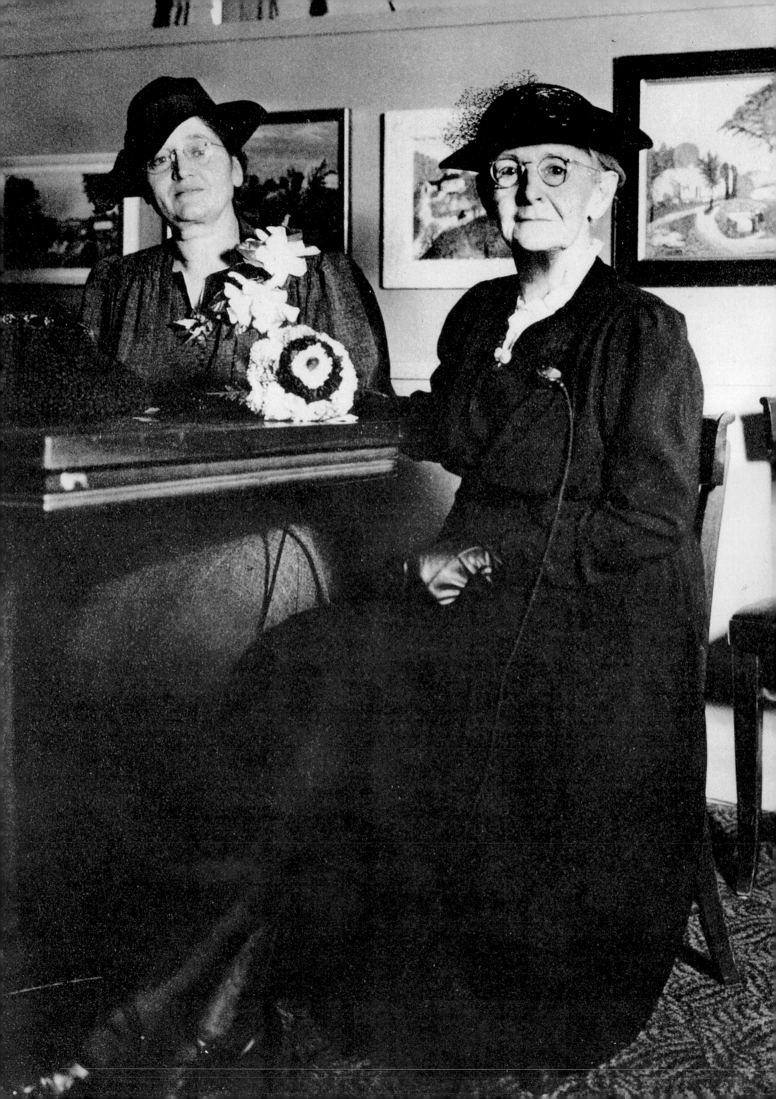

Grandma Moses:
Grandmother to the Nation

Essay by Lee Kogan

fenimore art museum®

COOPERSTOWN

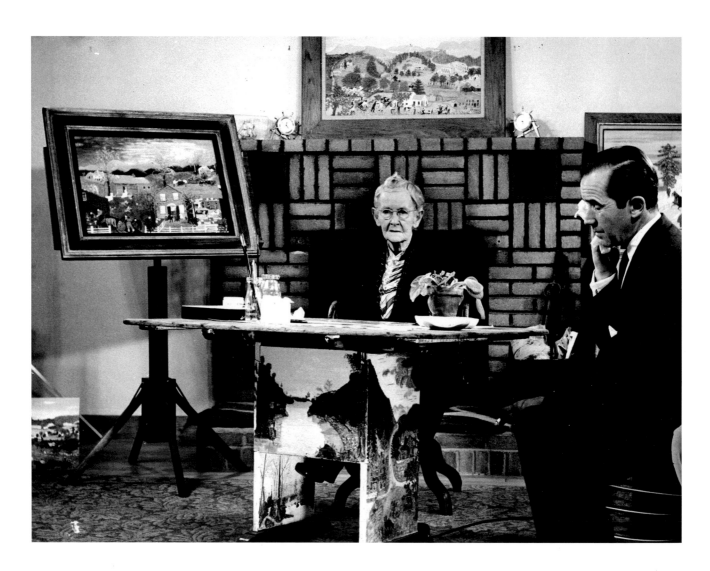

First published in 2007 by Fenimore Art Museum
Lake Road, P.O. Box 800, Cooperstown, New York 13326
www.nysha.org · www.fenimoreartmuseum.org

Published in conjunction with the exhibition *Grandma Moses: Grandmother to the Nation* on view at the Fenimore Art Museum, Cooperstown, New York, May 25–December 31, 2006; Reynolda House Museum of American Art, Winston-Salem, North Carolina, January 27–April 22, 2007; Hunter Museum of Art, Chattanooga, Tennessee, May 19–August 12, 2007; Crocker Art Museum, Sacramento, California, September 8, 2007–January 6, 2008; The John and Mable Ringling Museum, Sarasota, Florida, January 25–April 18, 2008.

The exhibition *Grandma Moses: Grandmother to the Nation* is made possible by generous grants from the Institute of Museum and Library Services, a federal agency, the National Endowment for the Arts, and The New York Council for the Humanities, a state affiliate of the National Endowment for the Humanities. Any views, findings, conclusions, or recommendations expressed in this publication do not necessarily represent those of the National Endowment for the Humanities.

NATIONAL ENDOWMENT FOR THE ARTS
A great nation deserves great art.

INSTITUTE *of* Museum *and* Library SERVICES

New York Council for the Humanities

ABOVE: *Grandma Moses and Edward R. Murrow during televised interview for "See It Now." June 29, 1955. Moses painted a version of* Sugaring Off *during and after the show.*

Preface and Acknowledgments

THE FENIMORE ART MUSEUM is fortunate to have two masterpieces by Anna Mary Robertson "Grandma" Moses in its illustrious collection of American folk art. These perennial favorites among visitors to Cooperstown, *The Old Oaken Bucket* (1943, plate 7) and *Sugaring Off* (1945, plate 13), were purchased by Susan Vanderpoel Clark, wife of the museum's great benefactor, Stephen Carlton Clark. It was Mrs. Clark's granddaughter and the museum's past board chairman, Jane Forbes Clark, who first suggested that the museum assemble a major exhibition of Moses' artwork. She immediately agreed to lend the four paintings in her collection, and the present traveling exhibition and catalogue are the fruits of her vision and generosity.

We have greatly benefited from the experience and wisdom of Jane Kallir, co-director of the Galerie St. Etienne, whose grandfather Otto Kallir brought Moses to the public's attention and guided her career. We are also grateful to Hildegard Bachert, long-time co-director of the gallery, whose knowledge of Moses' work is unparalleled. Their support of this project included advice on specific paintings, access to research archives, and editorial assistance on exhibition labels. Without their careful nurturing of Grandma Moses' legacy, and their substantive contributions to scholarship, this project would not have been possible.

Importantly, it was Jane who suggested approaching Karal Ann Marling to write a book about Moses, and we owe a debt of gratitude to Karal Ann for taking on this project so enthusiastically and sharing her ideas so generously. Her book, *Designs on the Heart: The Homemade Art of Grandma Moses* (Harvard University Press, 2005), is a welcome addition to the literature on Grandma Moses, and the exhibition is richer for her intellectual guidance.

In assimilating information from a wide variety of sources into coherent and accessible exhibition labels, we could not have been better served than by Lee Kogan, Curator of Special Exhibitions and Public Programs at the American Folk Art Museum. Lee's steadfast attention to detail and factual accuracy, along with her lively and engaging writing style, helped bring this exhibition together. Her work forms the body of the text in this volume.

We are also grateful to the agencies that funded this project — the Institute for Museum and Library Services, the National Endowment for the Arts, and the New York Council on the Humanities. This funding was vital to carrying out both the exhibition and its accompanying catalogue.

Our lenders to the exhibition are equally crucial. We deeply appreciate the twenty-two institutions and individuals who agreed to share their artworks with our audience. They are listed in this catalogue, alongside the work they contributed.

Grandma Moses: Grandmother to the Nation is a tribute to a remarkable woman, one who was old enough to remember Lincoln's death and lived long enough to see John F. Kennedy elected president. In her pictures Moses has woven past, present, and future together to teach us things of lasting value, to anchor us in a turbulent world, and to give us the right tools to shape a better future.

The oeuvre of Grandma Moses bridges a past that never stops and a future that is always coming. It blends tradition and innovation, and, most of all, memory and hope. We are very proud to share with you the life's work of one of America's greatest grandmothers, farmwives, and butter-makers, who put her golden years to good use and, in the end, left an enduring artistic legacy.

— Paul S. D'Ambrosio, Ph.D.
Vice President and Chief Curator, Fenimore Art Museum

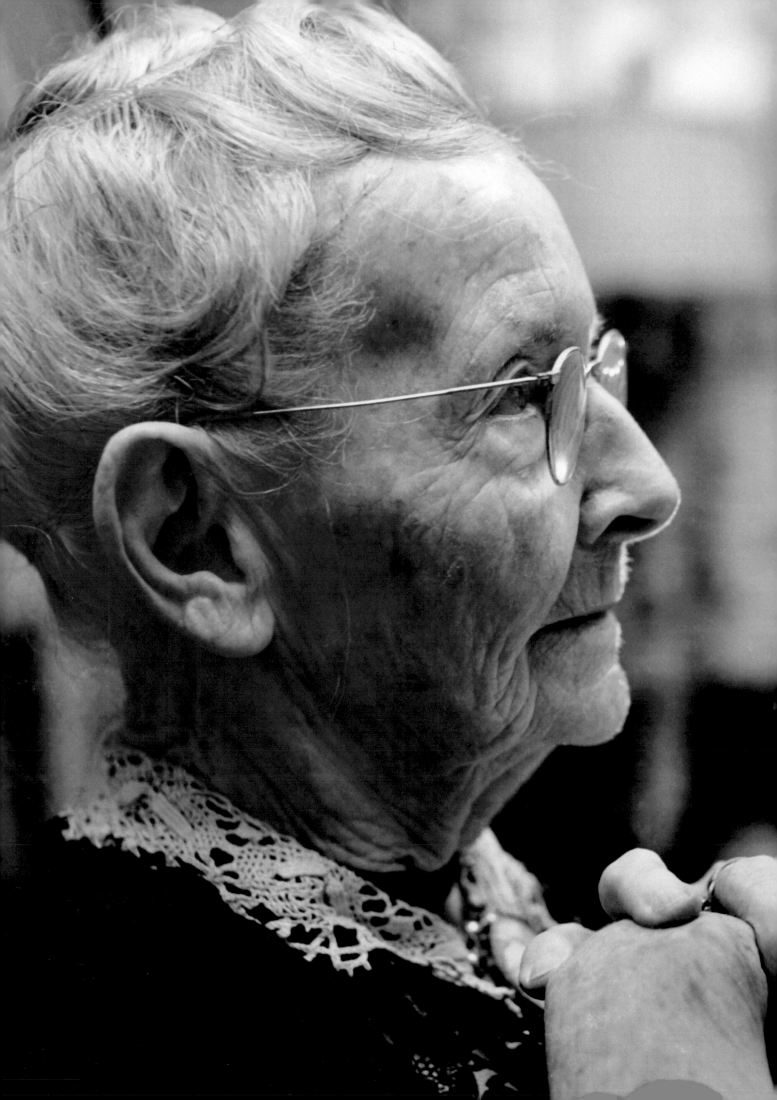

Grandma Moses: Grandmother to the Nation

By Lee Kogan

ANNA MARY ROBERTSON "Grandma" Moses (1860–1961) is one of the most celebrated Americans of the twentieth century and arguably our most famous self-taught artist. She attained celebrity status and received unprecedented media attention during her lifetime—rare for an artist—and her art and life tap into universal themes that maintain wide appeal to the present day.

The charismatic Moses embodied values that Americans revere: courage, energy, honesty, respect for work, modesty, a sense of humor, devotion to family, and reverence for nature. She was a master communicator, whose art embodies her individual strengths and ensures her a lasting place in the pantheon of American masters.

In the exhibition and catalogue *Grandma Moses: Grandmother to the Nation* we explore the discovery of Moses' paintings in 1938 and her rise to fame during the turbulent 1940s and 1950s, when she and her art represented American values during World War II and the ensuing Cold War. We examine the sources of her themes, her broad appeal, her unique artistic style, and her elevation to the status of icon.

Anna Mary Robertson Moses (1860–1961)

"If I hadn't started painting, I would have raised chickens"

Anna Mary Robertson was born September 7, 1860, into a farming family in Greenwich, New York. Anna demonstrated an early interest in art, which delighted her father, Russell. From the age of twelve she worked on local farms, and in 1887 she married Thomas Salmon Moses, a farmhand. The couple moved to Staunton, Virginia, to seek a better life in farming. Moses gave birth to ten children, five of whom died in infancy. The family moved back to New York State in 1905, settling in Eagle Bridge, about ten miles from Anna's birthplace. Thomas died in 1927, and Anna never remarried.

In the early 1930s, at the age of seventy, Moses embroidered a "worsted" picture for her granddaughter. She enjoyed the experience and created many more. However, when she developed arthritis these yarn pictures became too difficult to execute. Encouraged by her sister Celestia, she gradually switched from yarn to paint, the medium she would use for the remainder of her 101 years.

In 1935 an exhibition of Moses' paintings in a "woman's exchange" organized by the Thomas Drug Store in Hoosick Falls, New York, caught the interest and attention of New York collector Louis J. Caldor. Recognizing her talent, he purchased all of her paintings, then met her, purchased more, and obtained exhibitions and representation for her in New York City. There, collector Sidney Janis selected three of her paintings for a Museum of Modern Art exhibition.

Otto Kallir, director of the newly formed Galerie St. Etienne in New York, gave Moses her first solo exhibition in 1940. Three paintings sold and the show garnered several favorable reviews. Her unique style and homey themes captivated the public. Hundreds of national and international exhibitions followed, along with a significant body of scholarly articles and books. Virtually every book or catalogue that surveys twentieth-century self-taught artists includes an extensive entry on Grandma Moses.

The legacy of Grandma Moses, who painted until six months before her death on December 13, 1961, continues to draw interest from new and committed audiences, as well as debate from art communities and the public.

Woman's Work

"I painted for pleasure, to keep busy and to pass the time away, but I thought of it no more than of doing fancy work."

From her earliest years, Moses welcomed her role in the domestic sphere and was a thoroughly competent wife, mother, and caretaker. Like many women of her day, her needle-art skills were broad—she could sew, mend, embroider, and knit—and she often embellished her children's clothes with stars and other designs. Moses stitched as she pleased, primarily using an outline stitch and long and short stitches to fill in large design sections, and French knots for flowers and some leaves. Her main interest was in the overall appearance of her embroidery pictures, not in the intricacies and techniques of fancy needlework. These pictures were based on original designs, or inspired by drawings and reproductions of a variety of subjects.

Most of Moses' paintings are a celebration of women engaged in domestic life: washing, hanging out the clothes, preparing meals, and joining in family activities. In two self-portraits Moses portrayed herself not as an artist at her "tip-up" painting table but as a grandmother, as in *Rockabye* (plate 34), where she is featured sitting in a rocking chair with a baby on her lap. For Moses, painting was as natural a part of life as making jam, canning tomatoes, or rocking a baby. When she exhibited paintings at Gimbel's department store in 1940 in New York City, she brought, on request, home-made jams, jellies, bread, and cake. The ads for the event emphasized her domestic skills, which were part of her national appeal, and her edibles were displayed on a table beneath her pictures.

Moses did not challenge the traditional woman's role of her era. Quite the contrary—she was an equal partner in her marriage and enjoyed being a homemaker, mother, and grandmother. Yet she transcended that role with her creative energy and talent.

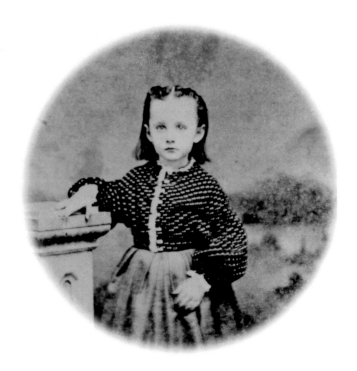

The Artist

"Before I start painting, I get a frame, and then I saw my Masonite board to fit the frame. I always thought it a good idea to build the sty before getting the pig. Likewise with young men—get the home before the wedding. I paint from the top down. From the sky, then the mountains, then the hills, then the houses, then the cattle, and then the people."

Grandma Moses, whose twenty-three-year painting career began when she was seventy-seven years old, showed interest in art from early childhood. She enjoyed drawing pictures on newsprint that her father bought for a penny a sheet. She later painted "lambscapes," as she called them, on sticks of wood, pieces of slate, and windowpanes. Her earliest surviving painting, found in 1948 behind several layers of wallpaper, was a landscape painted in 1918 in a style similar to that of nineteenth-century muralist painters such as Rufus Porter.

In the early 1930s, as Moses' farm chores and family responsibilities lessened, her daughter Anna challenged her to copy a picture using yarn as a medium. Moses found pleasure preparing and stitching her first "worsted" picture. She stitched many others on a variety of subjects: Scottish gardens, English cottage scenes, and rural scenes reminiscent of the nineteenth-century landscapes of John Constable. After arthritis forced her

ABOVE: *Anna Mary Robertson at the age of four, ca. 1864*

to give up needlework and take up painting, Moses devoted her full attention to art. She painted more than 1,500 pictures from 1935 until 1961, the year she died.

With intuitive compositional ability and talent as a colorist, Moses painted an idyllic world through the changing seasons and family holidays, especially Thanksgiving and Christmas. She borrowed images from Currier and Ives and other popular sources—greeting cards, magazines, and newspapers—and often traced motifs for details. She often did more than one rendition of a subject, but always varied details or changed the mood so that her pictures never appear as copies. Her mature painting style combined detailed foregrounds with stunning panoramic backgrounds. In her later years, her expressionistic painterly style was characterized by much looser brushwork.

Moses' paintings were representational, but many of the forms were set in a shallow picture plane. Her pictures combine simultaneous perspectives, flattened, abstract forms, and deep illusionistic vistas, creating a lively pattern punctuated by vibrant colors. Thematically, her paintings nostalgically recall earlier times and her universal messages are imbued with both the serenity and the spirited optimism that contribute to her broad appeal.

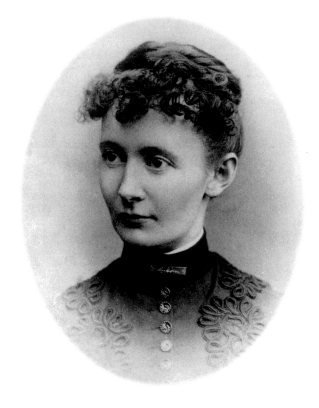

Anna Mary (Robertson) Moses as a bride, 1887

Celebrity

"I never dreamed that the pictures would bring in so much, and as for all that publicity, and as for all the fame which came to Grandma so late, that I am too old to care for now."

Painting against the stylistic trend of her time and ignoring art-world critics who dismissed her, Moses conveyed important visual messages about home, community, and nation that were understood by most Americans. With her artistic talent and down-home personality, Moses became, and remains, one of the best-known figures in American culture. During the last two decades of her life, she took on the persona of our nation's grandmother, and became an icon of Americana, as recognizable as Uncle Sam.

Grandma Moses was "discovered" in 1938, but it was her inclusion in a 1939 Museum of Modern Art exhibition and her 1940 one-woman show at the Galerie St. Etienne that created the path for her future celebrity. Reviews of the Galerie St. Etienne exhibition and the 1940 Gimbel's New York department store show rocketed Moses to stardom. Interestingly, Moses declined the invitation to attend her first solo exhibition, because it conflicted with her farm chores; the chance to visit a department store, however, was another matter. At Gimbel's, she had the opportunity to see more than her own pictures.

Moses was featured in countless newspaper and magazine articles, as well as on the new and instantly popular medium of television. She was photographed with such well-known figures as President Harry S. Truman, actress Lillian Gish, and illustrator Norman Rockwell. (Rockwell included Moses in two of his works, one of which was for the cover of the Christmas 1948 *Saturday Evening Post*.) In 1950 Jerome Hill produced a documentary film about Moses, with Archibald MacLeish as narrator. Moses gave an insightful and revealing interview with Edward R. Murrow on *See It Now* on December 13, 1955. She was featured on the cover of the Christmas 1953 issue of *Time* magazine and on the September 19, 1960, cover of *Life* magazine to celebrate

her 100th birthday. From the age of ninety, her birthdays were occasions for extensive national press coverage and interviews. In 1969, eight years after her death, the United States Government issued a commemorative six-cent stamp in her honor, bearing a detail of the painting *July Fourth*.

Icon and Ambassador

"Life is what we make it, always has been, always will be."

Moses' art had government approval during a time when there were strong attempts to impose political ideologies on art. When her first one-person exhibition opened in 1940, war raged in Europe. Posters prepared by the United States Office of War Information (OWI) addressed "Why we fight" issues by depicting homes and families in peaceful landscapes. The OWI used Moses' crisp winter scenes and comforting views of family at work and play to provide hope for those longing for such peaceful times.

Overseas exhibitions of Moses' paintings played an important international role during the Cold War between the United States and the former Soviet Union.

In 1950 the United States Information Service sponsored an exhibition of fifty of her paintings that traveled to Vienna, Munich, Salzburg, Berne, The Hague, and Paris. In 1955 a well-known art center in Bremen, Germany, presented a Grandma Moses exhibition that traveled to eight cities: Stuttgart, Cologne, Hamburg, London, Oslo, Aberdeen, Edinburgh, and Glasgow—the last three sponsored by the Arts Council of Great Britain. With these exhibitions, Moses' paintings served as ambassadors of American home life and culture to the world.

From 1962 to 1964 the exhibition *A Life's History in 40 Pictures* toured Europe and the Soviet Union under the auspices of the United States government as part of an image-making campaign. Moses' pictures of cozy country dwellings paralleled the government-sponsored trade shows and fairs overseas, highlighting the modern American home as the primary symbol of peace and prosperity. In addition, it is important to note that three Grandma Moses exhibitions toured Japanese cities in 1987, 1995, and 2005. Her egalitarian art was accessible to all audiences as it stressed universal themes of work, home, family, community, country, and a love of nature.

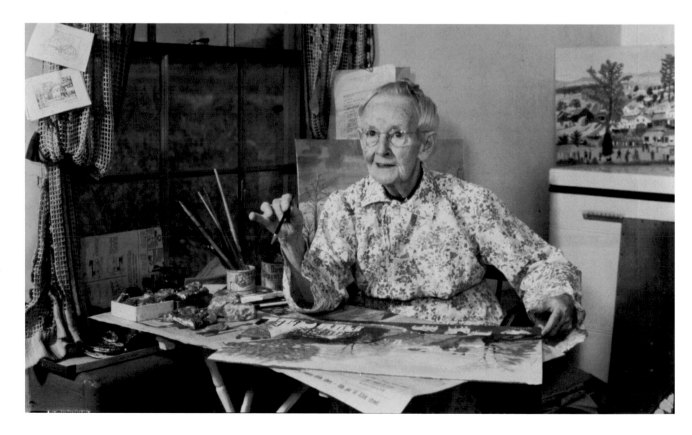

Grandma Moses Painting, 1952 (Photograph by Ifor Thomas)

From Lipstick to Bisquick

"Paintin's not important. The important thing is keepin' busy."

As Abstract Expressionist artists such as Jackson Pollock rose to prominence, Grandma Moses provided an art alternative that the broader American public could more easily embrace.

Reproductions of her paintings in a variety of sizes and formats, and on products such as greeting cards, printed fabric, tableware, and lipstick, brought Moses' pictures to millions of Americans. While critics claimed that the products debased the artist's image, defenders countered that they made her pictures available to the masses and helped develop a larger audience to appreciate her art. Her themes reflected faith in America's future—a subject for which post–World War II Americans longed. From 1946 to 1950 reproductions of Moses' paintings were used to advertise everything from lipstick and flour to Wheaties and Bisquick, and by 1947 the Hallmark Company held Moses' greeting-card license. In 1949 Riverdale Fabrics created drapery fabrics using her paintings. That same year, the Atlas China Company created a series of limited-edition plates based on four Moses paintings. Sold at department stores like Macy's, the plates were used as decorative objects or as practical tableware.

Grandma Moses products gave the artist extensive national exposure. She was fortunate to have an intelligent and respectful art representative, Otto Kallir, who skillfully steered her public career. In 1952 Kallir established Grandma Moses Properties, Inc. to assign and protect copyright of reproductions of her works. To the present day, Kallir's gallery, the Galerie St. Etienne, carefully monitors use of Moses' images.

Memory and Hope

"What a strange thing is memory, and hope; one looks backward, the other forward. The one is of today, the other is the tomorrow. Memory is history recorded in our brain, memory is a painter; it paints pictures of the past and of the day."

The life and art of Grandma Moses can be viewed from a variety of perspectives. Though she was not part of any art movement of her time, her art resonates with American Regionalism. American art turned toward abstraction in the 1940s, but public taste continued to respond to the pictorial art of the Regionalists, who rose to prominence in the 1930s. The villages, sugaring-off rituals, ice-skating pictures, and harvest scenes that brought Grandma Moses such fame may be looked at as part of a broader movement concerned with idealization of rural life. This impulse in American art was strongly supported by corporate America, which used works by Regionalist painters Thomas Hart Benton and Grant Wood in ads and product design.

While Moses' sense of place and history were frequently generalized, her imaginative restructuring of the landscape and her narratives within the landscapes captured the essence of northern New York State and regional Virginia, where she had lived. Her paintings, endowed with familiarity and optimism, simultaneously look backward and forward.

Creating a large body of work late in life, Moses was essentially performing a life review that allowed her to focus her lens where and how she wished. Her art transcended all evidence of personal hardship and pain as she created a world in which people functioned organically within an overarching harmonious natural order. Her unbroken faith and positivism carry a universal message—the importance of family and community—that will always be timely.

Grandma Moses: Grandmother to the Nation was curated by Lee Kogan, Curator of Special Exhibitions and Public Programs at the American Folk Art Museum in New York City, and Karal Ann Marling, Professor of History at the University of Minnesota. We also acknowledge the ongoing scholarship of Jane Kallir and Hildegard Bachert, co-directors of the Galerie St. Etienne in New York. All Grandma Moses quotations are from her autobiography, *My Life's History* (New York: Harper and Brothers, 1948, 1950, 1952).

Illustrated Works

The "K" numbers refer to the numbers in "Catalogue of the Works" in *Grandma Moses*
(New York: Harry N. Abrams, 1973) by Otto Kallir.

Plate 1

Cairo, 1933

Wool yarn, 10 x 8 inches · **K3W**

Moses' daughter Anna suggested that she try thread painting as a hobby.
The idea appealed to Moses and she enjoyed embroidering pictures
until arthritis in her hands became so painful she was forced to stop.
Her subjects were often from copied sources. This small embroidery of
Cairo, Egypt, for example, features a mosque or palace with an onion-
shaped dome.

Moses was not interested in fancy stitchery for its own sake but
instead used thread like a painter uses color to delineate form. Her
stitches were largely free form but she preferred variations of the long,
short, and brick stitch for fillers, the chain stitch for outlining, and
occasional French knots for flowers. Moses layered her stitches, placing
different colors side by side to effectively create shading. She later used
a similar layering technique to achieve shading in her paintings.

Collection of the Bennington Museum, Bennington, Vermont

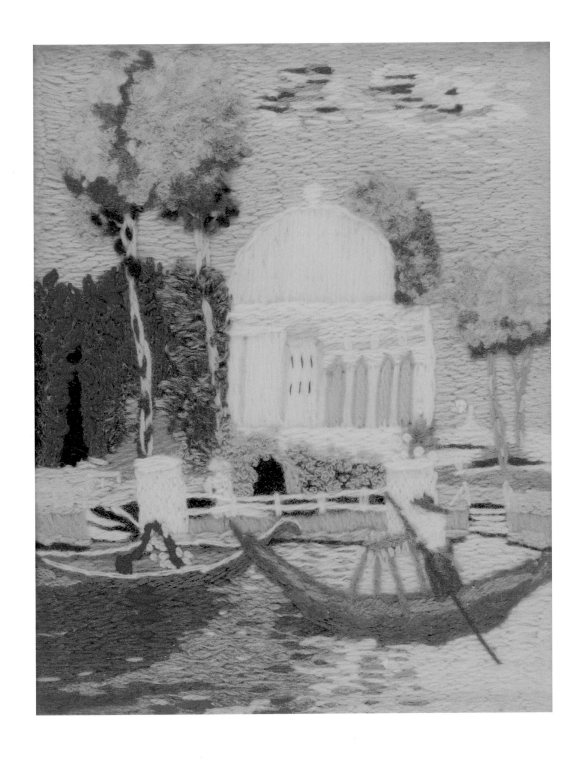

13

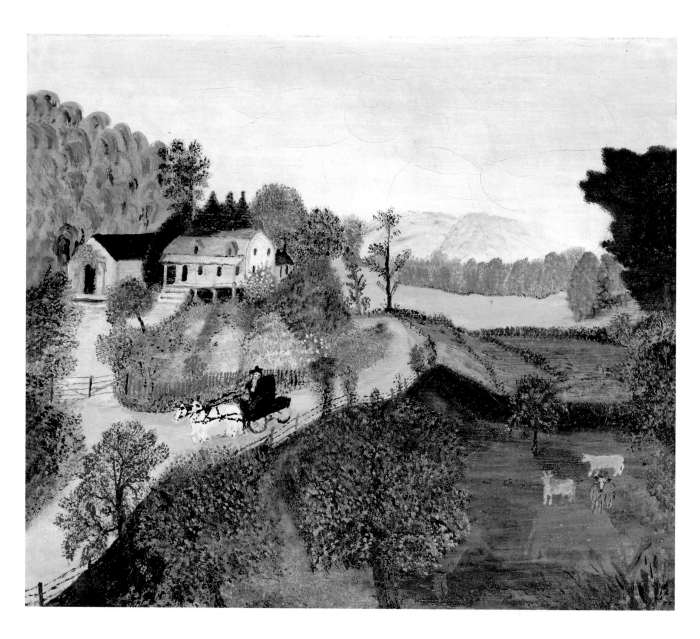

Plate 2

The Old House at the Bend of the Road, 1939

Oil on canvas, 10¾ x 12½ inches · **K40**

This painting's small format is characteristic of Moses' early work.
It was easy to manage on her "tip-up" table. Some hallmarks of Moses'
mature style are present, such as her strong sense of composition
and color. The artist varied her brushstrokes from smooth for the sky
to staccato motions for the leaves as she layered color on color.
Details were often traced from a cache of images Moses kept, which
she adapted and rearranged.

Collection of the Bennington Museum, Bennington, Vermont

Plate 3

Possible self-portrait, ca. 1940

Oil on oilcloth (found as backing for plate 1, *Cairo*), 10 x 7¾ inches · **K1522**

This picture might be a self-portrait and, if it is, it is one of only three and would have been taken from a photograph of the artist at an earlier age. The others are *In the Studio* and *Rockabye* (plate 34). This portrait was found on the back of the worsted *Cairo* but cannot be accurately dated. However, the color palette in the background, the distinct contour separations of the figure from the background, the handling of the jewelry, and the use of oilcloth as a ground all indicate an early date. The 1939 painting *The Old House at the Bend in the Road* (plate 2) has comparable elements.

Moses was not comfortable painting human figures naturalistically and she was not prideful, so painting images of herself was a particular challenge.

Collection of the Bennington Museum, Bennington, Vermont

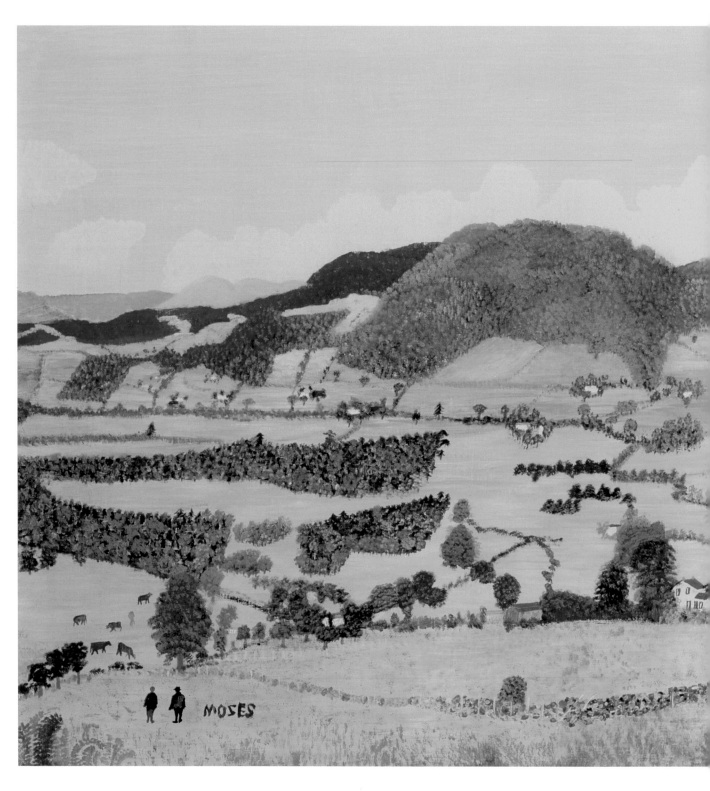

Plate 4

My Hills of Home, 1941

Oil on board, 17 3/4 x 36 inches · **K99**

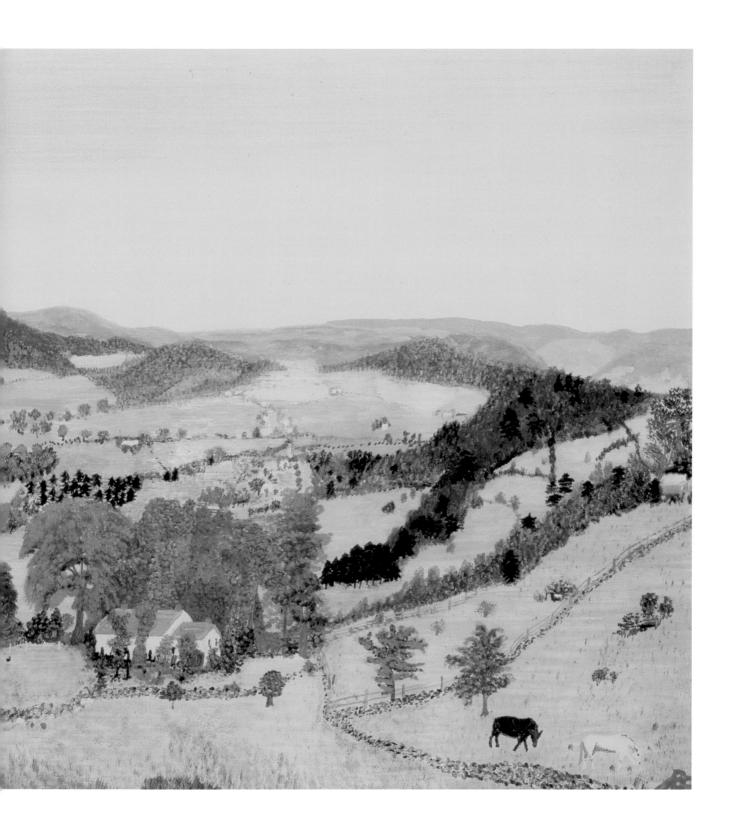

In her autobiography Moses wrote about green, the predominant color of this subdued panoramic summer landscape: "Often I get at a loss to know what shade of green, and there are a hundred trees that have each three or four shades of green in them. I look at a tree and I see the limbs, and then the next part of the tree is a dark, dark black green, then I have got to make a lighter green, and so on. And then on the outside, it'll either be yellow green, or whitish green, that's the way the trees are shaded." By layering color, Moses achieved delicate texture and tonal variety from carefully controlled dotted brushwork on the top layer of paint.

Memorial Art Gallery of the University of Rochester; Marion Stratton Gould Fund; photograph courtesy of The Galerie St. Etienne, New York

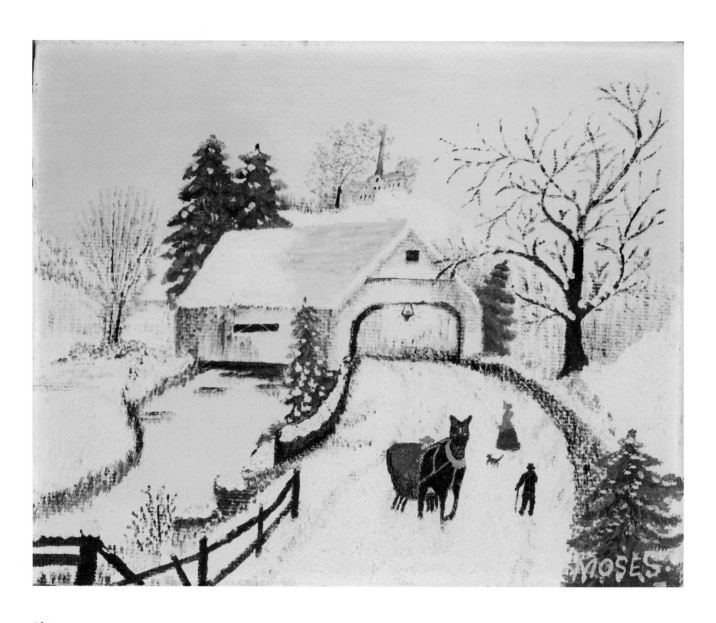

Plate 5

The Old Covered Bridge, ca. 1941

Oil on composition board, 8⅝ x 10⅝ inches · **K77**

In this painting, Moses presents a close look at a covered bridge, flattening the form and creating simultaneous perspectives of both frontal and side views. An overhead gas lamp provides illumination for the horse and sleigh that have just emerged.

The covered bridge was an important motif for Moses, one she used both in her worsted pictures and in her paintings. In 1820 Connecticut engineer Ithiel Town patented the "Town Lattice Truss," which became the country's most popular covered bridge style. The roof and sides were designed to help protect the wood from rot and decay, not to protect travelers from weather.

Wadsworth Atheneum Museum of Art, Hartford, Conn.; gift of Mr. and Mrs. Andrew Galbraith Carey; photograph courtesy of The Galerie St. Etienne, New York

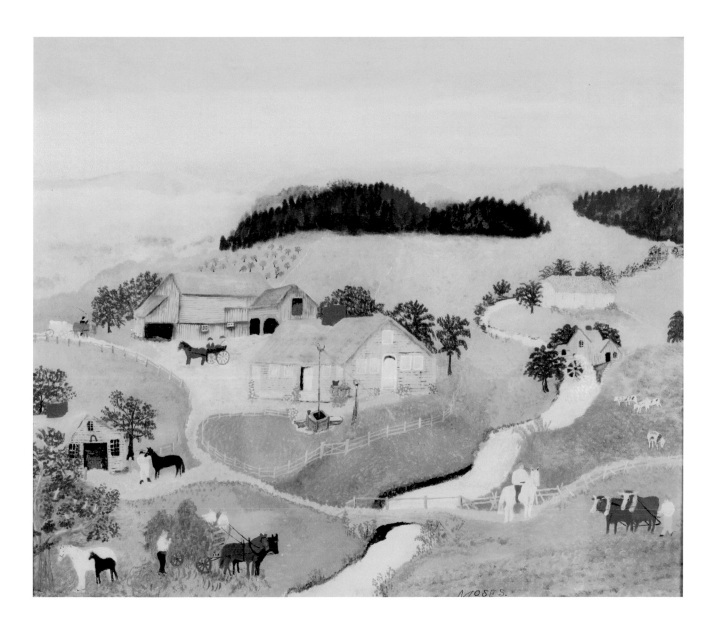

Plate 6

Home of Hezekiah King, 1776, 1943

Casein on pressed wood, 19 x 23½ inches · **K217**

Moses' great-grandfather Hezekiah King was born in Amenia, New York, in 1755. When he was twenty he left home and traveled to the Cambridge valley, where he built a home in about 1778. It was destroyed by fire in 1800. The shingled home had hewn sills "eight or ten inches thick, from 12 to 20 inches wide."

Collection of Phoenix Art Museum; gift of Mrs. N. A. Bogdan, New York,
in memory of Mr. Louis Cates

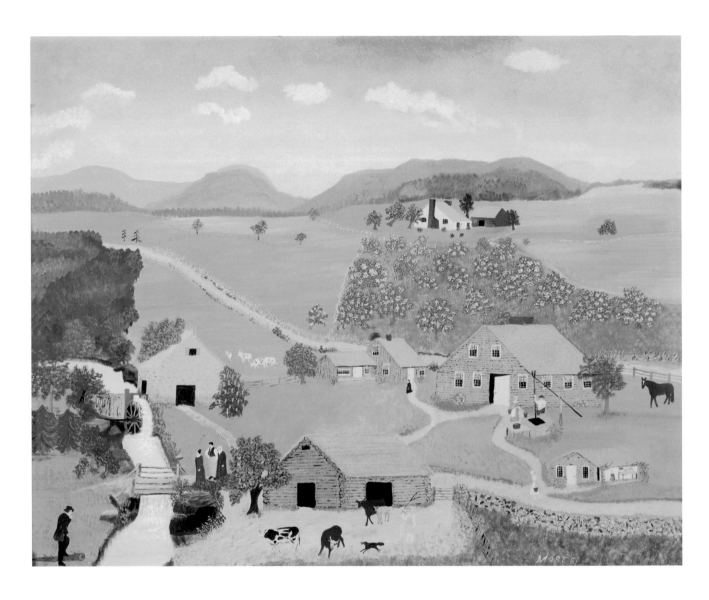

Plate 7

The Old Oaken Bucket, 1943

Mixed media on board, 24 x 30 inches · **K228**

While working on the farm of Mrs. David Burch, Moses was told that the farm's well inspired the song, "The Old Oaken Bucket." Paul Dennis, a relative of Mrs. Burch, had fallen in love with a neighbor's daughter. Her parents objected to the relationship, however, and the relationship languished. Dennis went to sea for several years. According to Mrs. Burch, while away, he wrote the poem and upon returning home gave the poem to a printer. Samuel Woodworth published the poem as his own in 1817 and Dennis was never credited.

In 1941 the first version of this painting won a New York State prize at the Syracuse Museum of Fine Arts (now the Everson Museum of Art). In her desire to satisfy her patrons, Moses repeated the subject many times, but no two paintings were alike.

Collection of the Fenimore Art Museum, Cooperstown, New York

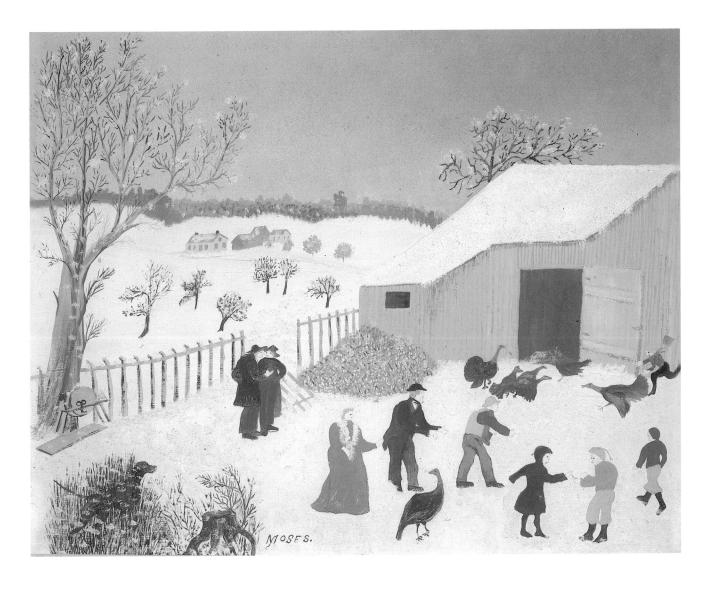

Plate 8

Thanksgiving Turkey, 1943

Oil on pressed wood, 16 x 20 inches · **K293**

One of the artist's most popular subjects incorporates details from
two magazine illustrations. Moses never slavishly copied her sources,
but varied the composition by adding, subtracting, expanding, and
compressing elements. She continued to use the motif of a boy chasing
a turkey but in a broadened setting, with the barn and grindstone placed
farther apart. Here the figures are more casually arranged, with the
exception of the boy, and two pairs of figures seem totally unconcerned
with the impending grim event.

*The Metropolitan Museum of Art, New York; bequest of Mary Stillman Harkness, 1950
(50.145.375); photograph courtesy of The Galerie St. Etienne, New York*

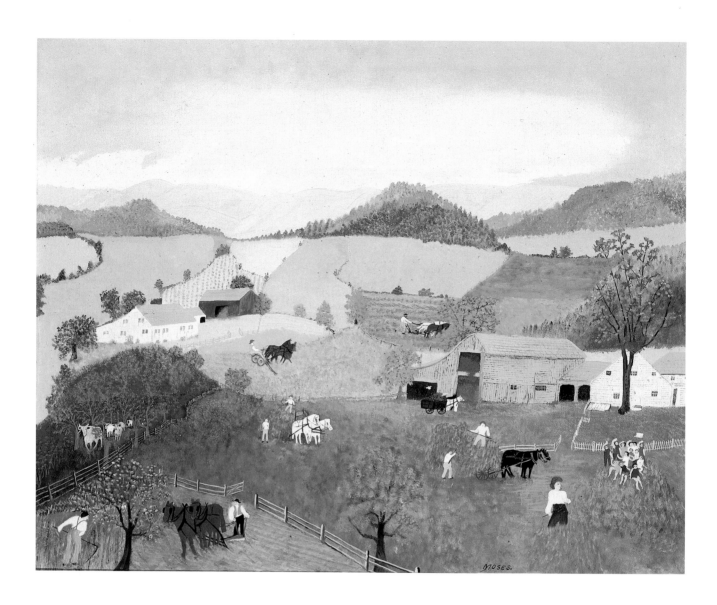

Plate 9

The McDonnell Farm, 1943

Oil on canvas, 24 x 30 inches · **K313**

This painting shows people at work and children at play. One can imagine the cluster of children in the right foreground singing "Old MacDonald Had a Farm." Field hands are haying and cultivating the fields within a spacious farm setting. Moses' personal musings enliven the narrative and reveal much of her personality and spirit.

Recalling life in the nineteenth century, Moses wrote: "Way back in 1840, the farms were large and they had many hired men to till the land as they raised nearly all their own food, such as wheat, corn, oats, rye, and lots of livestock, horses, cows, sheep. They spun the wool for yarn, to be woven into cloth for blankets and clothing."

The Phillips Collection, Washington, D.C.; photograph courtesy of The Galerie
St. Etienne, New York

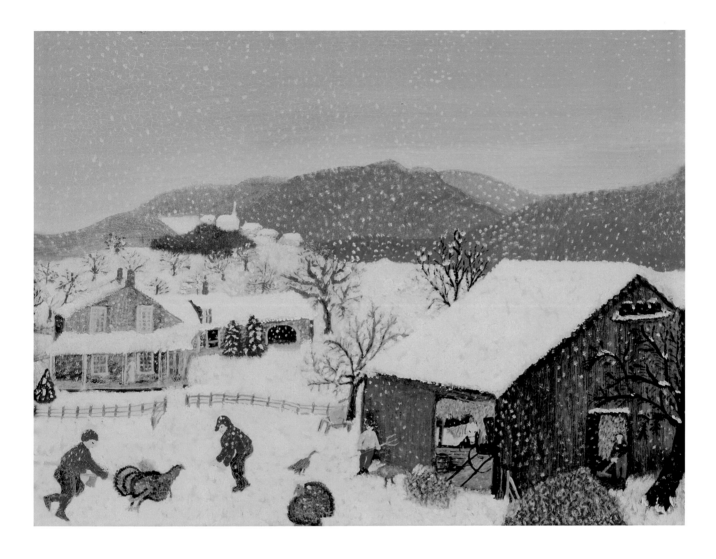

Plate 10

Catching the Thanksgiving Turkey, ca. 1943

Oil and glitter on board, 12 ¼ x 16 ¼ inches · **K325**

This painting was inspired by a small black-and-white print. In Moses'
many renditions of the scene, she varied the composition, the number
of figures, the position of the hapless bird, and the weather. However,
she did not seem to use any of the specific elements from the print.
This fully developed landscape expands the original, more compressed
print image.

Moses felt some ambivalence about the ritual slaughter of the
barnyard bird, writing, "Why do we think we must have turkey for
Thanksgiving? Just because turkeys were plentiful and they didn't have
other kinds of meat. Now we have abundance of other kinds of luxuries.
Poor turkey. He has but one life to give for his country."

San Diego Museum of Art; gift of Pliny F. Munger

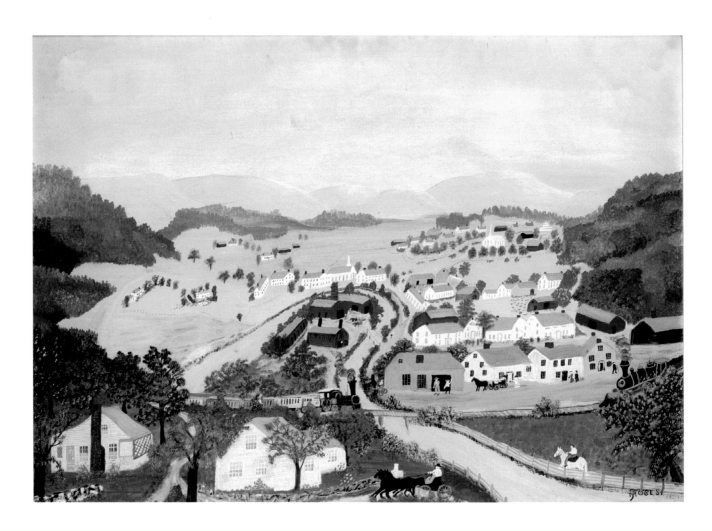

Plate 11

Hoosick Falls, N.Y., 1944

Oil on board, 23 x 33 inches · **K374**

Moses' artistic professional life began in Hoosick Falls, New York,
when art collector Louis Caldor saw her work in Thomas Drug Store.
He met with the artist, bought many of her paintings, and went back to
New York determined to find representation for her and an exhibition
for her work. Hoosick Falls, the closest town to Moses' farmstead, is where
she is buried.

Moses' serene painting was an antidote for the disruptions caused
by World War II.

Southern Vermont Arts Center, Manchester, Vermont

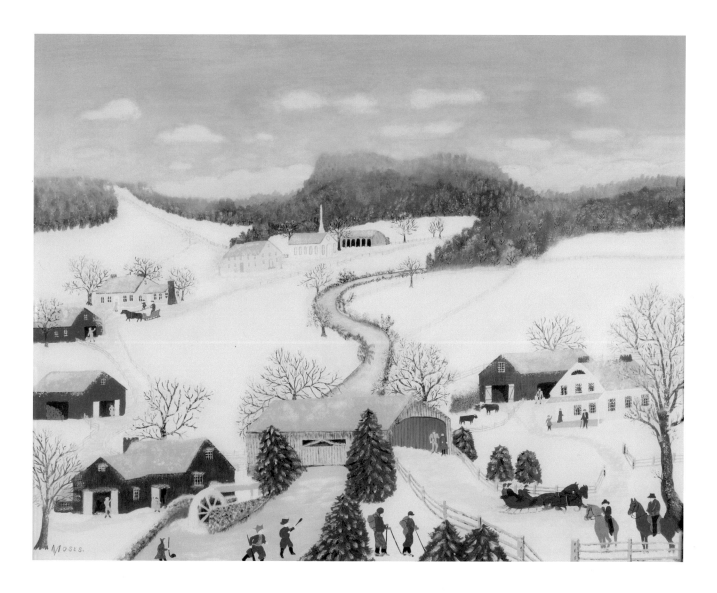

Plate 12

Over the River to Grandma's, 1944

Oil on pressed wood, 24 x 29⁷/₈ inches · **K433a**

Details vary in the two versions of *Over the River to Grandma's* in this
exhibition. For example, the large covered bridge illustrated here, is
different from the lattice bridge of the 1947 picture (plate 17). Here, a
horizontal band of figures fills the lower foreground—children enjoying
the frozen stream, people with backpacks, walking through the snow
assisted by ski poles.

The positive values of home and family imparted by the multiple
Over the River paintings were the very themes that captivated Presidents
Truman and Eisenhower and launched Moses' role as a cultural
ambassador. Exhibitions of her paintings were sent to many European
cities during the Cold War.

Collection Michael Owen/Jim Yost

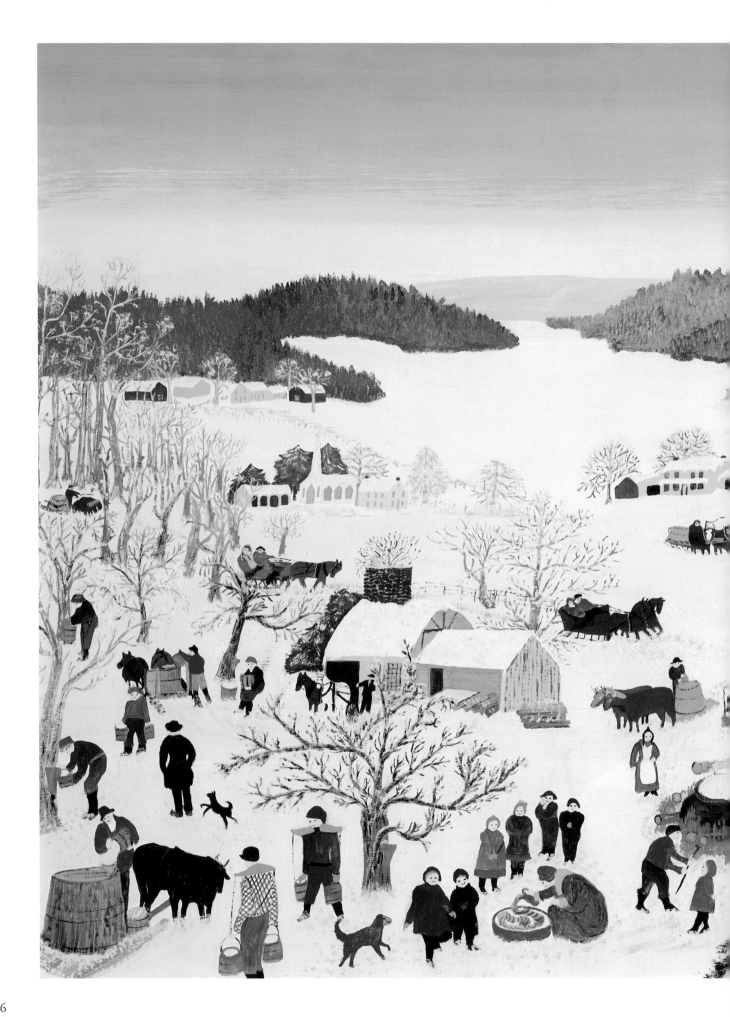

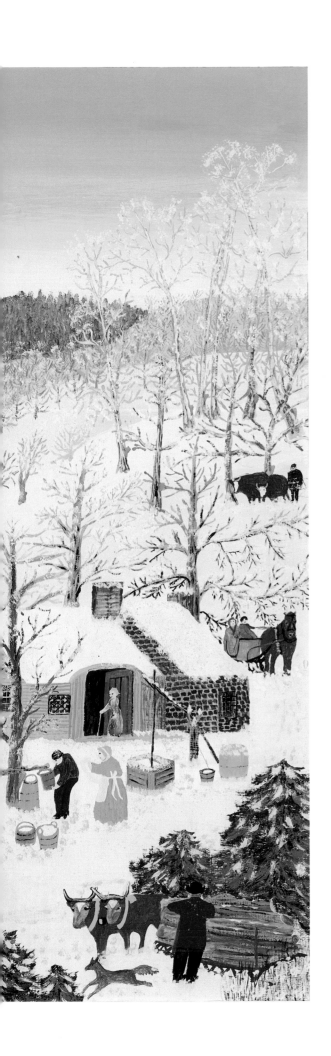

Plate 13

Sugaring Off, 1945

Oil on canvas, 26 ¼ x 31 inches · **K505**

Sugaring Off is perhaps Moses' favorite subject and she returned to it again and again throughout her career. It was inspired by the Currier and Ives lithograph *Maple Sugaring, Early Spring in the Northern Woods* (1870). Moses gathered hundreds of magazine and newspaper clippings of barns, houses, people, animals, and machines to help her compose her pictures. She traced the outlines of her selected forms and then filled in basic detail. Faces were not naturalistic but consisted of two dots for eyes and one curved stroke for a smiling mouth. A huge kettle is heating to boil the syrup, and a person in the mid-foreground is preparing a sweet taffy known as "jack wax" in the snow while children watch.

This crisp masterpiece epitomizes Moses' mature landscape style, where people of all ages live in harmony with nature.

Collection of the Fenimore Art Museum, Cooperstown, New York

Plate 14

Bennington, 1945

Oil on pressed wood, 17¾ x 25¾ inches · **K567**

Bennington, Vermont, held personal and historical memories for Moses. The artist frequently traveled there to visit her daughter Anna, who lived on Ellis Street. After Anna's death, Moses cared for her granddaughters, Zoan and Frances, until her son-in-law remarried.

There is no hint of personal tragedy in this painting. Moses experienced hardship and difficulties in life but she had a special gift for transcending life's darker moments, determined to seek life's positive promise.

Collection of the Bennington Museum, Bennington, Vermont; photograph courtesy of The Galerie St. Etienne, New York

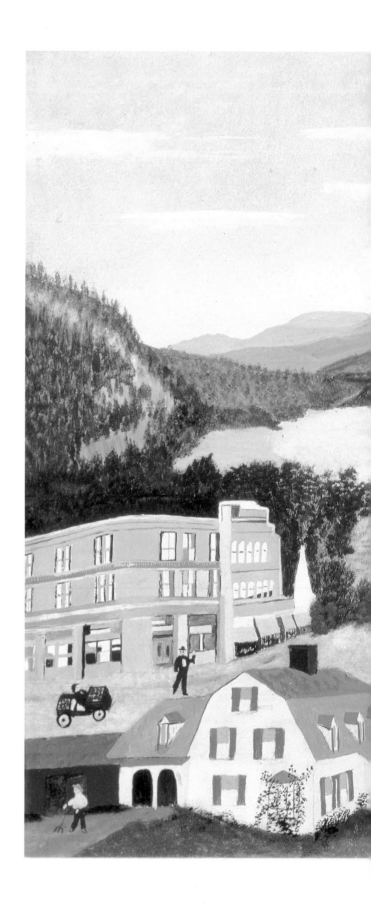

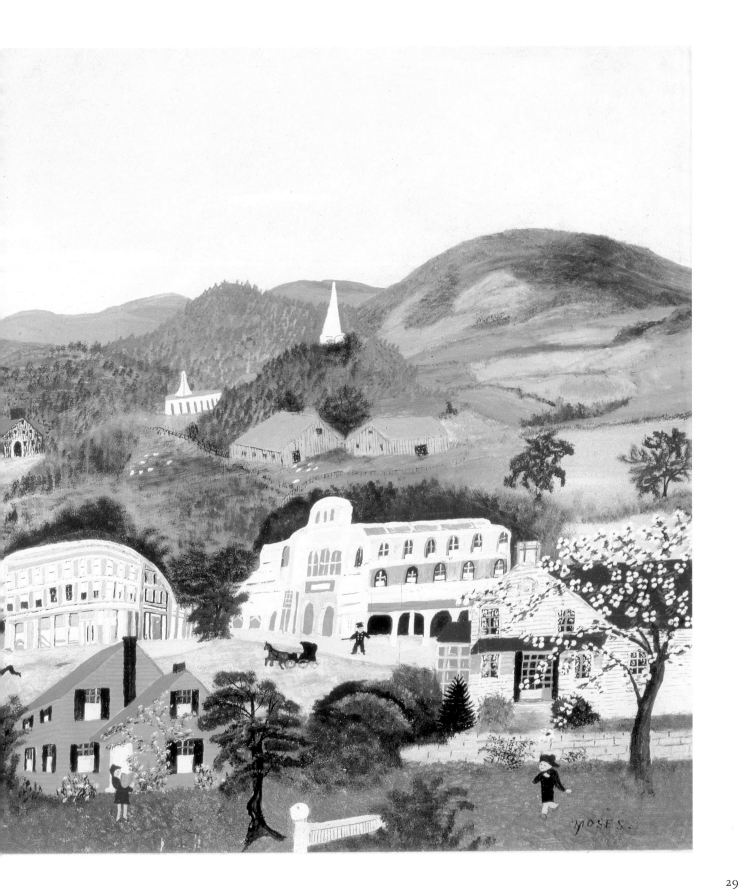

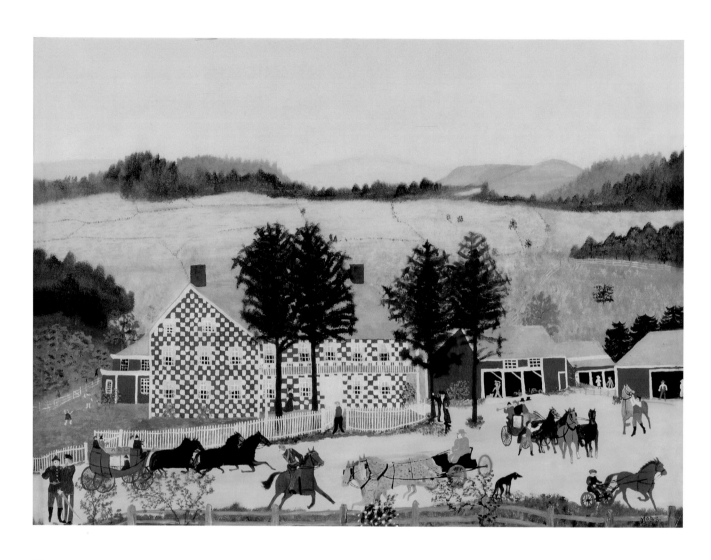

Plate 15

The Old Checkered House, 1853, 1946

Oil on pressed wood, 14 x 20¾ inches · **K571**

People often wrote to Moses requesting this subject, and the artist painted more than twenty versions of the Checkered House, an inn in Cambridge, New York, between 1941 and 1959. While she did not favor painting on demand, she did not want to disappoint her supporters.

The distinctive checkered house was built in 1765 a few miles south of the village and served as a stop where stagecoach drivers changed horses. During the Revolutionary War it was taken over by the British in 1777. Following the Battle of Bennington, it was used as a hospital. During the War of 1812 the inn was a bivouac for volunteers marching to battlefields at Lake Champlain. In 1824 General Lafayette resided there for a brief period. It was destroyed by fire during Moses' lifetime.

Collection of the Bennington Museum, Bennington, Vermont

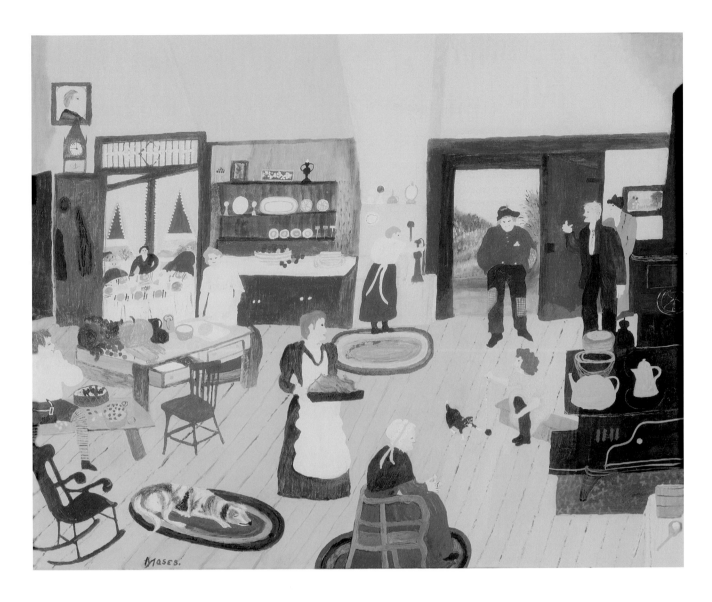

Plate 16

A Tramp on Christmas Day, 1946

Oil on academy board, 16 x 19 ⅞ inches · **K595**

This rare interior genre picture exemplifies hospitality. A scruffy guest
in patched pants is welcomed to share Christmas dinner. At least
three generations are depicted in the household: the mother holds a
large turkey, grandmother is seated and occupied with some handwork,
a young daughter plays with a cat, and a son appears to be sampling
goodies. A table is set for dinner in the adjoining room. Reaching out to
the less fortunate was an ethical value Moses supported, especially
at Christmas.

Moses was not comfortable painting interiors because she found it
difficult to delineate a detailed human figure or deal with close-ups.
Yet she often met the challenge with extraordinary results. This picture
appears to be based on an unidentified print source.

Collections of the Shelburne Museum, Shelburne, Vermont; photograph courtesy of
The Galerie St. Etienne, New York

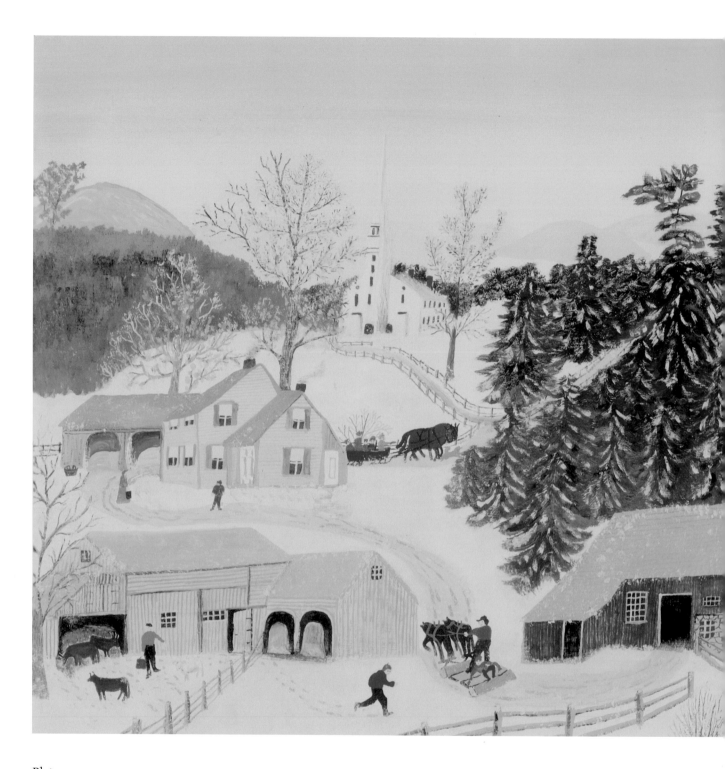

Plate 17

Over the River to Grandma's, 1947

Oil and glitter on pressed wood, 19½ x 41¾ inches · **K659**

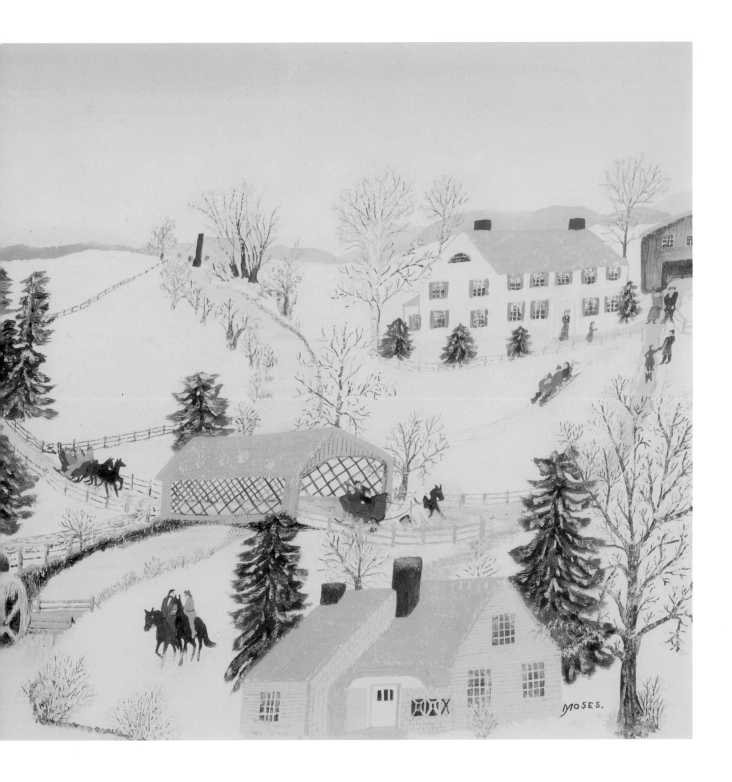

This painting was inspired by the well-known popular song "Over the River and Through the Woods," as well as by the artist's personal recollections. Moses' words help us understand the evocative meaning of this landscape: "This was my grandmother King's old house, and when Thanksgiving came we were all expected home to dinner. There were many young people like ourselves, and we would have a grand time in playing." Although travel in winter was difficult, her family made every effort to get together on special occasions.

Ala Story, a Moses supporter, encouraged her to try a larger format. This painting, the widest in the exhibition, shows the artist's willingness to try new things. Its size made working on her "tip-up" table unwieldy,

and in her final years working in the larger size became too cumbersome. The subject was a favorite among Moses collectors and she painted the scene many times, always varying the details.

Hunter Museum of American Art, Chattanooga, Tennessee; promised gift of Karen G. and Paul John Kruesi III in honor of Ruth S. and A. William Holmberg

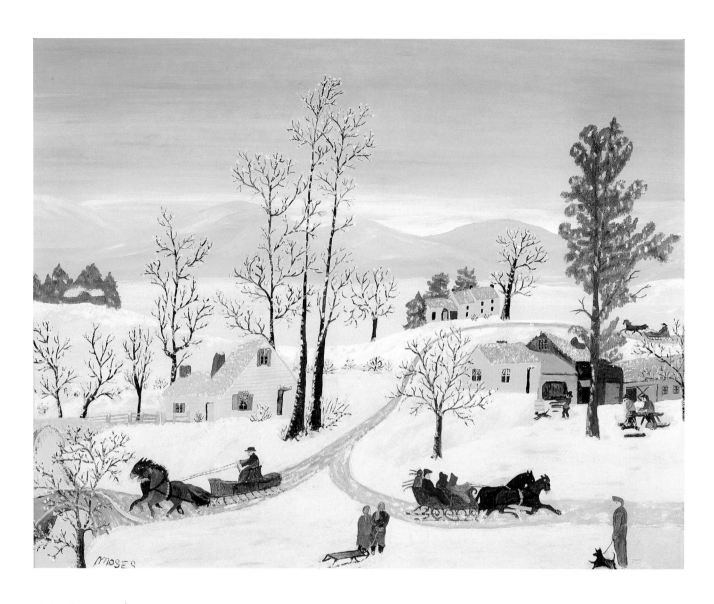

Plate 18

Dividing of the Ways, 1947

Oil, glitter, and tempera on pressed wood, 16 x 20 inches · **K701**

In *Dividing of the Ways* men cut and stack wood while two children
and a man watch two horse-driven sleighs part from a common path
and drive off in opposite directions. The artist presented the picture
in a straightforward manner, though the viewer might be tempted to
think metaphorically of the divided road as life's many choices.

The white and gray landscape draws attention to Moses' technical
skills. The subtle striated sky, pale distant hills, dabs of snow on tree
branches, and evergreen foliage lend an atmospheric serenity to this
thoughtful narrative.

Collection of the American Folk Art Museum, New York; gift of The Galerie St. Etienne,
* New York, in memory of Otto Kallir (1983.10.001); photograph courtesy of*
* The Galerie St. Etienne, New York*

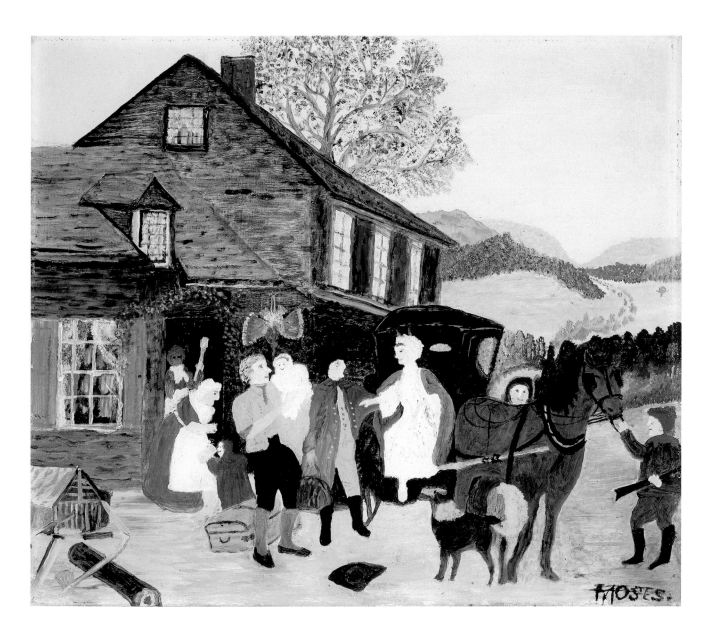

Plate 19

The Daughter's Homecoming, ca. 1947

Oil on pressed wood, 12 1/8 x 14 1/8 inches · **K1514a**

This painting appears to have been copied from an unidentified print
source. The theme might have had special meaning for the artist since
she valued family and recognized the importance of reunions.

Collection of Lauren Rogers Museum of Art, Laurel, Mississippi. An LRMA purchase
with partial funds given by the Steber Foundation; photograph courtesy of
The Galerie St. Etienne, New York

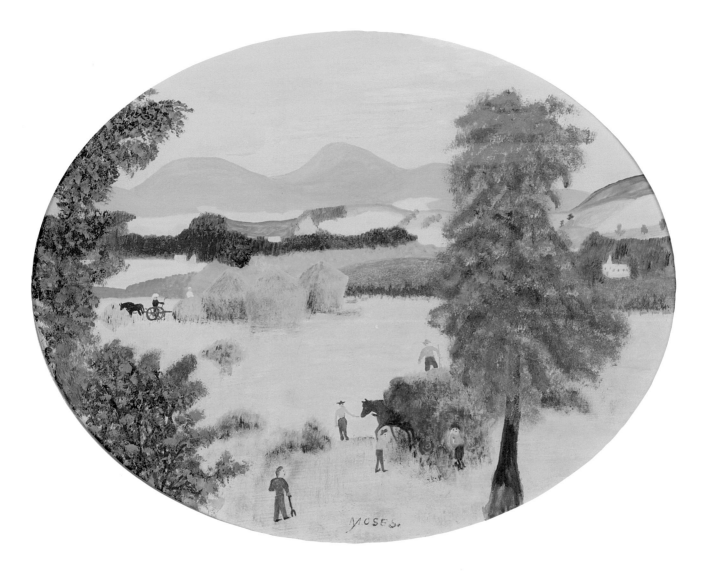

Plate 20

The Harvest, 1948

Oil on pressed wood, 11 x 14 inches · **K739**

This rare oval format demonstrates the artist's willingness to experiment, as well as her skill in adapting her usual compositional scale to suit the frame. Two trees in the foreground have carefully painted layered green foliage, which creates the illusion of depth. Houses and a church spire peek through the background foliage and fields.

The summer hay harvest was essential for the survival of farm life, and the work of loading and stacking hay is clearly outlined here.

The Parrish Art Museum, Southampton, New York; gift of Dr. Otto Kallir (1960.8)

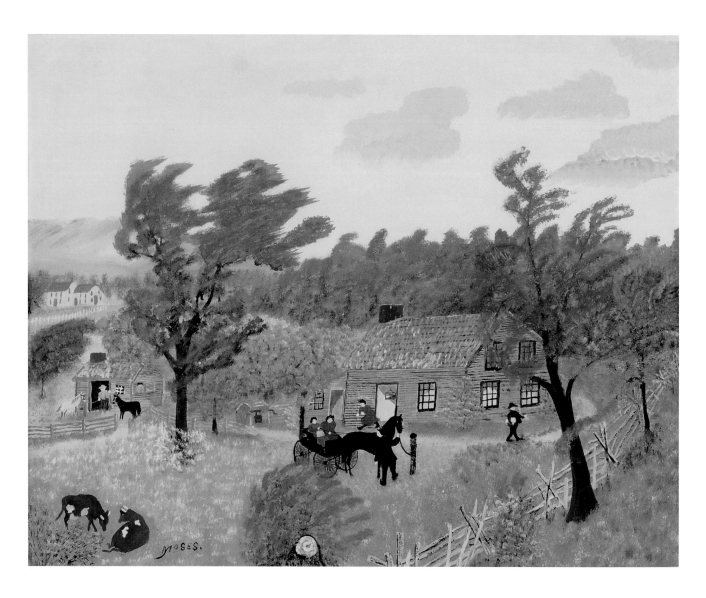

Plate 21

The Hitching Post, 1948

Oil on pressed wood, 15 x 19¼ inches · **K785**

Hitching posts were nineteenth-century parking spaces for horses.
They proliferated in front of houses, inns, and other public buildings.
The hitching post in this picture is central in the composition; the narra-
tive elements suggest the arrival of two women. While the anecdotal
narrative is calm, a turbulent tone is set by two large trees on either side
of the central figures, with foliage swaying from strong winds. Trees
in the background veering toward the right echo the disquiet, and gray
clouds suggest a possible storm.

It is interesting that Moses often selected titles that were not
necessarily the major theme of the picture, inviting the viewer to find
the element that she referenced in the title.

Collection of Jane Forbes Clark

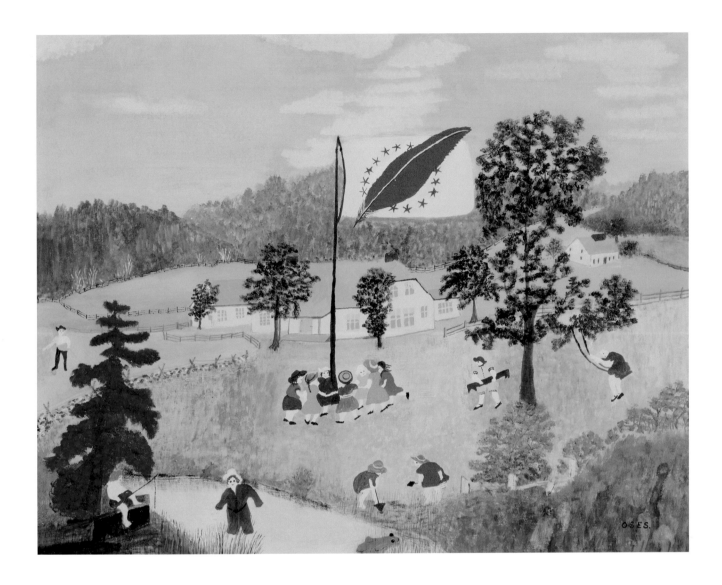

Plate 22

The Red Feather, 1948

Oil on board, 16 x 20 inches · **K797**

Moses was commissioned by the United Way (or one of its affiliated
organizations, such as Community Chest) to paint this work and
to incorporate the organization's logo, the Red Feather, its symbol for
organized charity fundraising.

Author Dorothy Canfield Fisher encouraged Moses to support
the annual Community Chest "Red Feather" campaign by contributing
paintings for fundraisers.

On loan from United Way of America

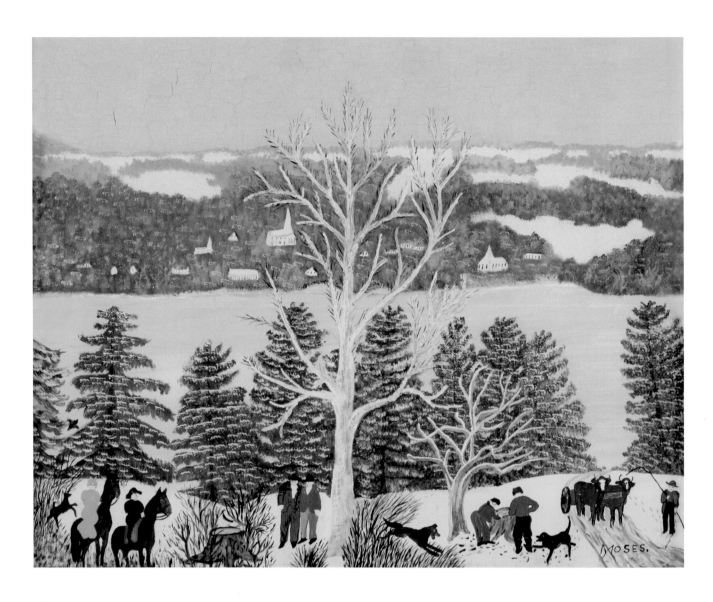

Plate 23

Cazenovia Lake, 1948

Oil and tempera on board, 16 x 20 inches · **K802**

This stylized painting has five distinct bands outlining the composition
and includes fourteen lively figures in the foreground. Two vertical trees
with outstretched bare limbs counterbalance the strong horizontality of
the composition.

Cazenovia is a village on the western edge of Madison County,
New York, in the Syracuse area.

Collection Everson Museum of Art, Museum Purchase, 52.592

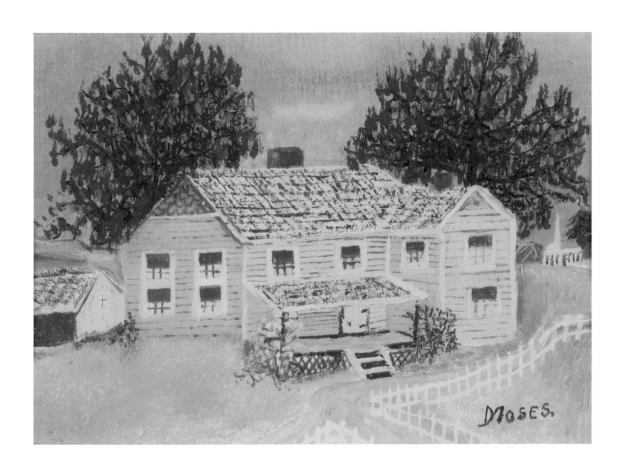

Plate 24

Aunt Margaret's House, 1950

Oil on canvas, 5½ x 7 inches · **K934**

Aunt Margaret's side-gabled house with an addition is featured close to
the picture plane in this small, delicately painted picture. While this
painting does not have an original frame, many of Moses' early paintings
do. According to her autobiography, prior to 1944 Moses usually prepared
a frame before she began to paint. She wrote, "I always thought it a good
idea to build the sty before getting the pig. Likewise with young men—
get the home before the wedding."

 This small painting may have been a commission and probably does
not refer to anyone in Moses' family.

Collection of Jane Forbes Clark

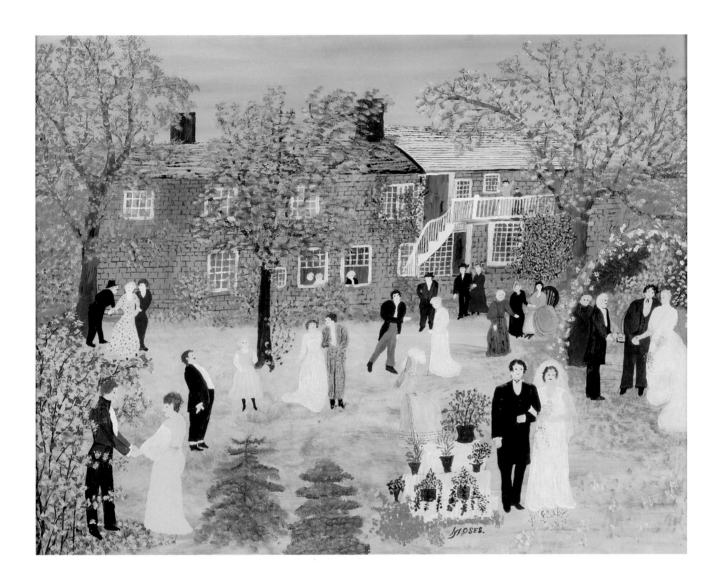

Plate 25

A Country Wedding, 1951

Oil on pressed wood, 17 x 22 inches · **K968**

This animated genre scene captures a summer wedding reception
in a garden behind what appears to be a large brick inn. The bride and
groom clasp arms as though posing for an unseen photographer.
A tiered stand of flowering plants embellishes the picture and offers
a symbolic reference to a fruitful future.

　　Moses' sense of perspective is naturalistically realized as the figures
moving from foreground to mid-ground recede in size. The artist's
sense of humor is evident by the presence of a stout gentleman with an
exaggerated belly.

*Collection of the Bennington Museum, Bennington, Vermont; photograph courtesy
of The Galerie St. Etienne, New York*

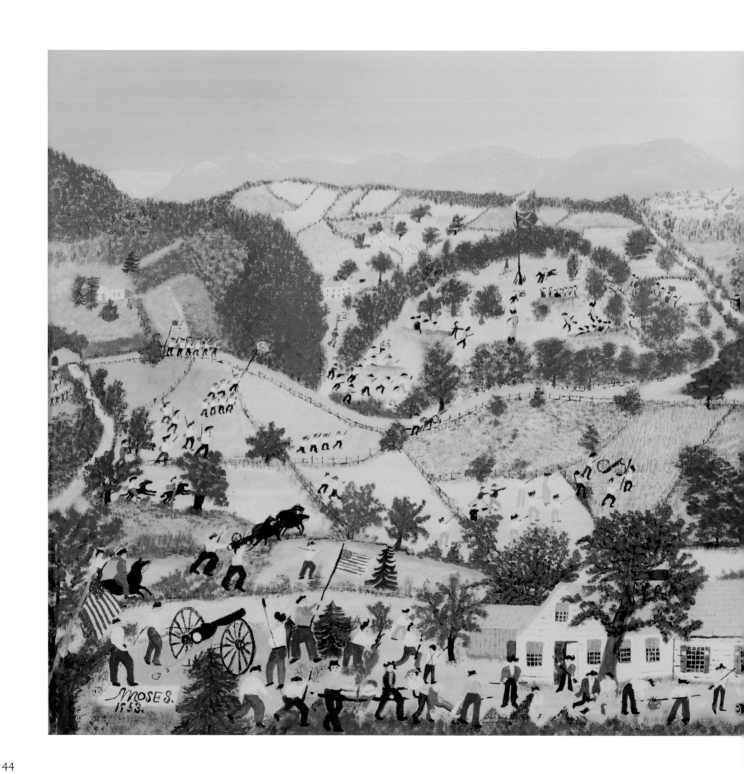

Plate 26

Battle of Bennington, 1953

Tempera on board, 17 ½ x 29 ¾ inches · **K1113**

This painting recalls an important Revolutionary War battle that took place five miles from Bennington, Vermont, in August 1777. British general Baum approached the town with an army of mercenaries prepared to capture horses and supplies. He and his army were caught by surprise and surrounded by the Green Mountain militia under General John Stark. Stark's victory led to the British surrender at Saratoga, New York, a few months later.

After Moses accepted the invitation from the National Society of the Daughters of the American Revolution to paint this history picture, she researched details of Revolutionary War uniforms for accuracy.

Gift of Anna Mary Robertson Moses, National Society Daughters of the
American Revolution

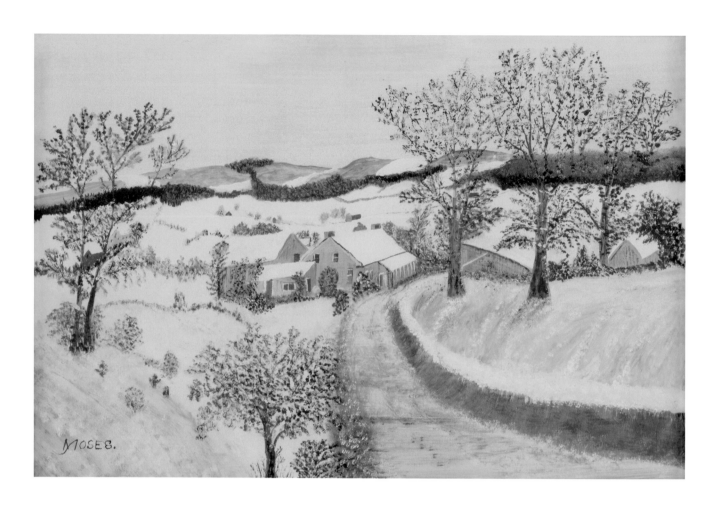

Plate 27

Baker Home, 1954

Oil on pressed wood, 12 x 18 inches · **K1150**

It was atypical for Moses to tint snow with blue paint. When criticized for using too much white for snow Moses wrote: "And the snow, they tell me I should shade it more or use more blue, but I have looked at the snow and looked at the snow, and I can see no blue, sometimes there is a little shadow, like the shadow of a tree, but that would be gray, instead of blue, as I see it…"

Mrs. Baker was a close friend of Grandma Moses, and often drove her and her daughter, Winona, to various places.

Collection of the Bennington Museum, Bennington, Vermont

Plate 28

White Christmas, 1954

Oil on pressed board, 23¾ x 19¾ inches · **K1162**

Poems and songs were important to Moses throughout her life and she occasionally titled paintings after them. This painting's title was undoubtedly influenced by Irving Berlin's song written in 1940, and the film that was released in 1954.

The sentiment of the song is reflected in Moses' serene winter landscape, with its nostalgic memories and comforting snapshots of home. With Cold War anxieties gripping the nation during the mid-1950s, this landscape would have been particularly reassuring.

Private Collection; photograph courtesy of The Galerie St. Etienne, New York

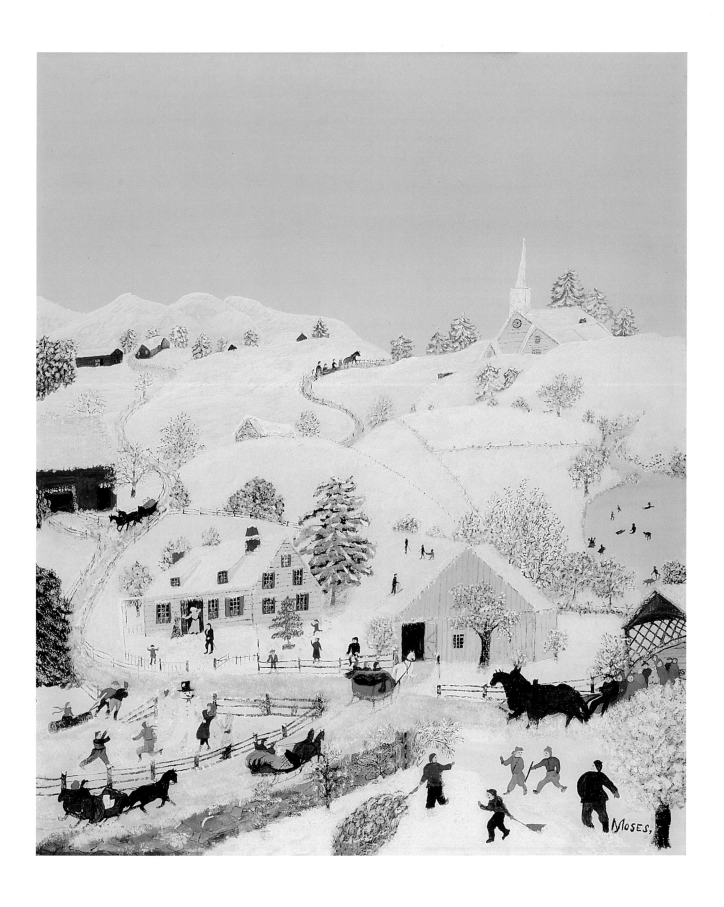

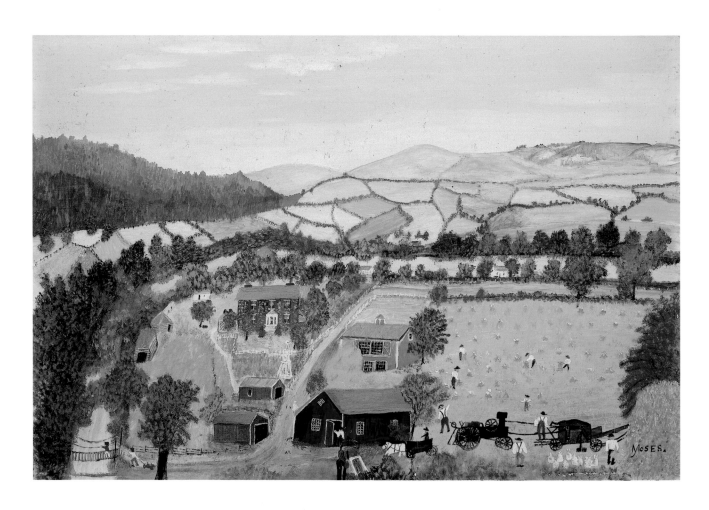

Plate 29

Calhoun, 1955

Oil on pressed board, 16¾ x 24 inches · **K1200**

Here, Moses achieves depth by using bright colors for the foreground
details and pastel hues in the background. The farm buildings and brick
residence occupy the lower half of the scene. In the fields, men are
harvesting oats using an engine-driven threshing machine. Calhoun was
perhaps the owner of the farm or its location.

National Museum of Women in the Arts; gift of Wallace and Wilhelmina Holladay;
courtesy of The Galerie St. Etienne, New York

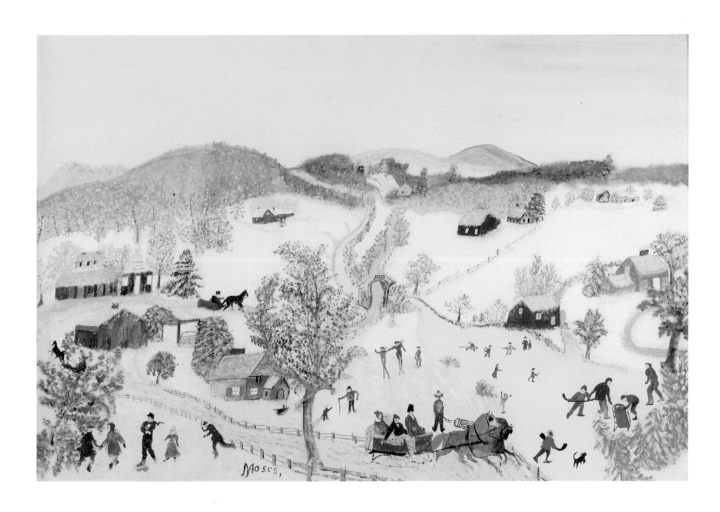

Plate 30

January, 1956

Oil and glitter on pressed wood, 15 7/8 x 24 1/8 inches · **K1210**

As in so many of her winter scenes, Moses achieved a shimmering snow
effect by using craft shop glitter, despite advice that she would receive
negative criticism by the art world.

Collection of Jane Forbes Clark

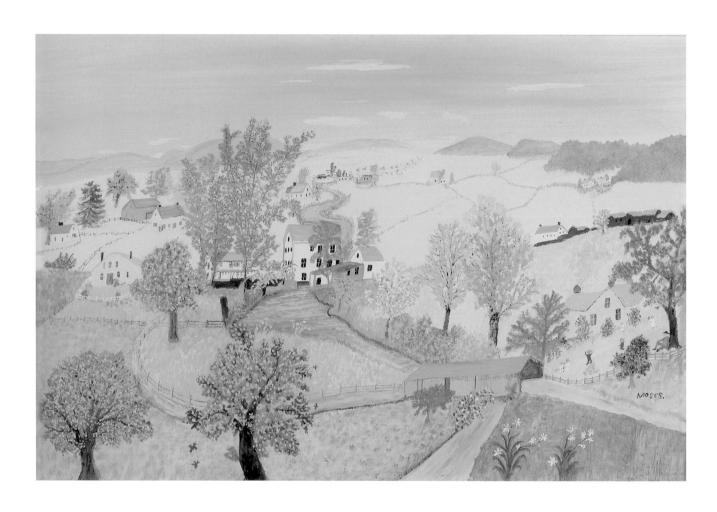

Plate 31

May, 1956

Oil on pressed wood, 16 x 24 inches · **K1227**

In this panoramic landscape Moses captures the essence of spring.
The birds, blooming flowers, lush green fields, meadows, hills, swaying
trees, and distant blue mountains are refreshing and full of promise.
Tidy yellow-and-white houses, farm buildings, and a covered bridge
all contribute to this unified composition. It is delicately colored but
punctuated with bright barn red on the farm buildings.

Collection of Jane Forbes Clark

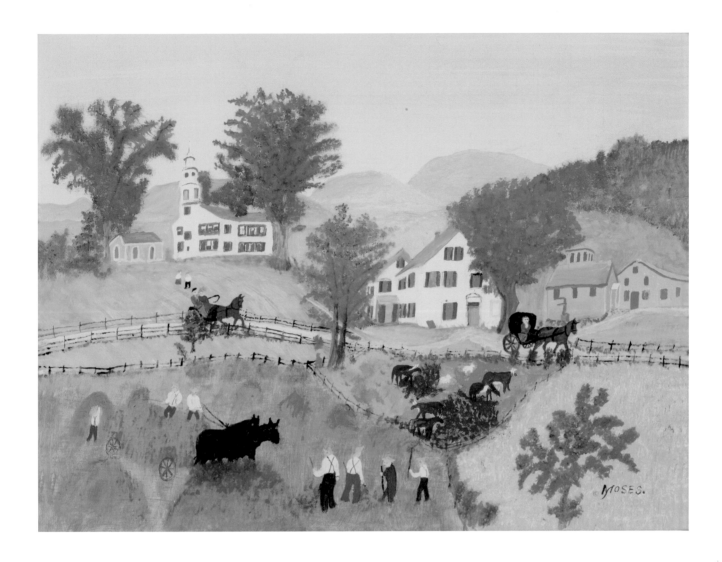

Plate 32

Haying, 1956

Oil on pressed wood, 11 7/8 x 15 3/4 inches · **K1260**

Before the advent of mechanized vehicles, haying enlisted every member
of the family as well as additional hired laborers. Hay was essential to feed
animals during the winter, when fields were frozen or covered with snow.
Hay was gathered in bundles, loaded on wagons, and stored in barns.

Collections of the Shelburne Museum, Shelburne, Vermont

Plate 33

Lattice Bridge, 1957

Oil on board, 15⅞ x 24 inches · **K1264**

In this winter scene, silvery trees are interspersed around several
farms. Moses included a mill in mid-ground and a covered bridge in
the right foreground. She animated the setting with figures at work
and at play—sleighs, horses, a prancing dog, and a wagon. The title
encourages the viewer to focus on the lattice-sided covered bridge with
its single lane about to be crossed by a pedestrian and a sleigh.

Collection of Mr. & Mrs. Edwin C. Andrews

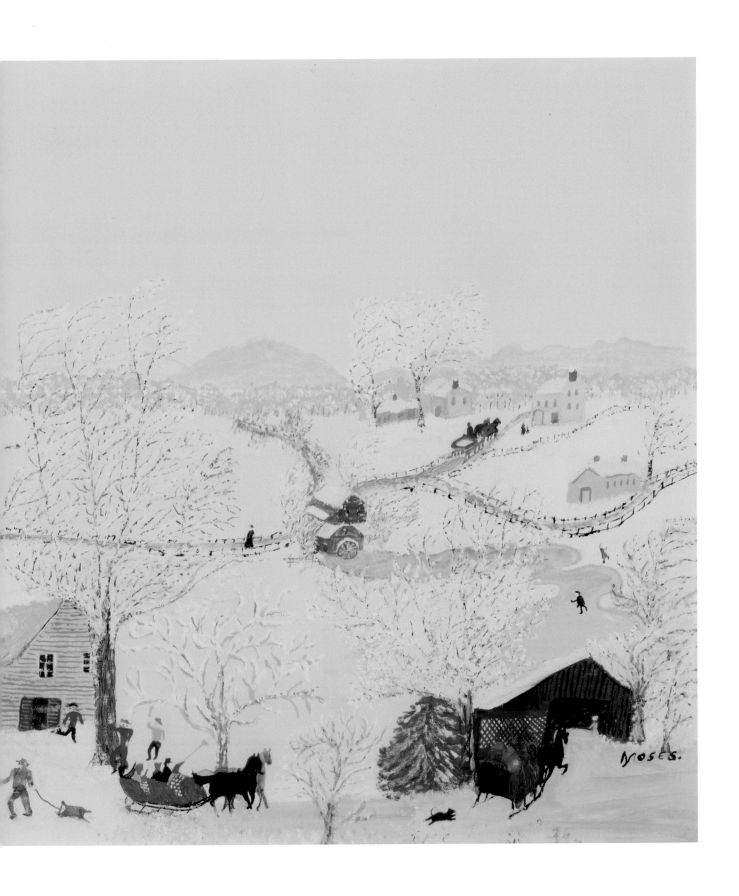

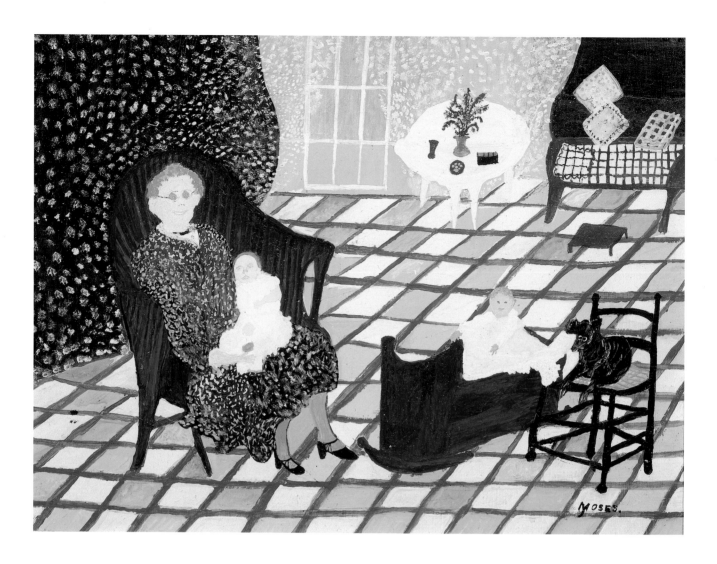

Plate 34

Rockabye, 1957

Oil on canvas, 11 7/8 x 16 inches · **K1303**

Rockabye is one of only three self-portraits. In this intimate work
Moses presents herself in a traditional role, family nurturer, within a
domestic setting.

 The scene is enlivened with patterns of alternating squares
on the floor, billowing drapery, checkered upholstery, and gauzy back-
ground curtains.

Private Collection; photograph courtesy of The Galerie St. Etienne, New York

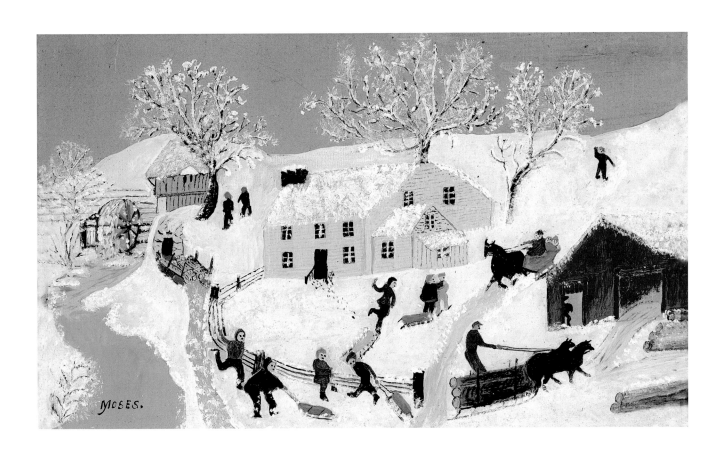

Plate 35

Pull Boys, 1957

Oil on pressed wood, 7 7/8 x 12 7/8 inches · **K1319**

In this painting, children are pulling sleds uphill, expending time and
energy for the thrill of the brief ride down. A man drives two horses
pulling logs into a farm building, and another man drives a graceful
one-horse sleigh with two children dressed in red. Despite its title,
Pull Boys focuses not on work but on children having fun.

Collection of the Bennington Museum, Bennington, Vermont

Plate 36

Fishermen, 1959

Oil on board, 16 x 24 inches · **K1381**

In this view three boys are engaged in one of America's favorite pastimes—fishing at the side of a lake. Moses chose the title to highlight one small vignette in this charming village scene.

Collection of Mr. & Mrs. Edwin C. Andrews; photograph courtesy of
The Galerie St. Etienne, New York

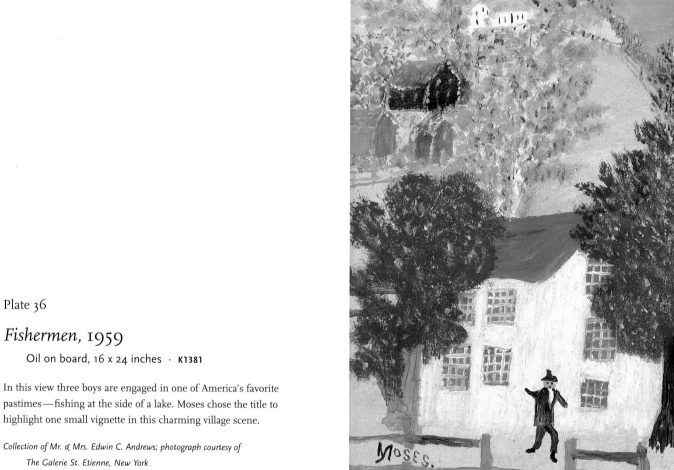

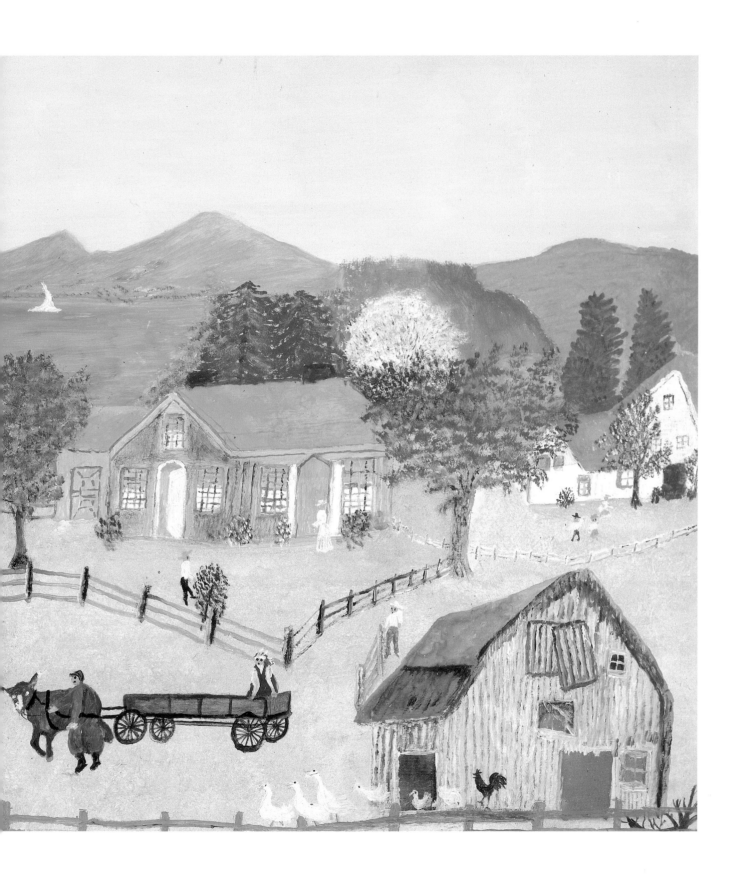

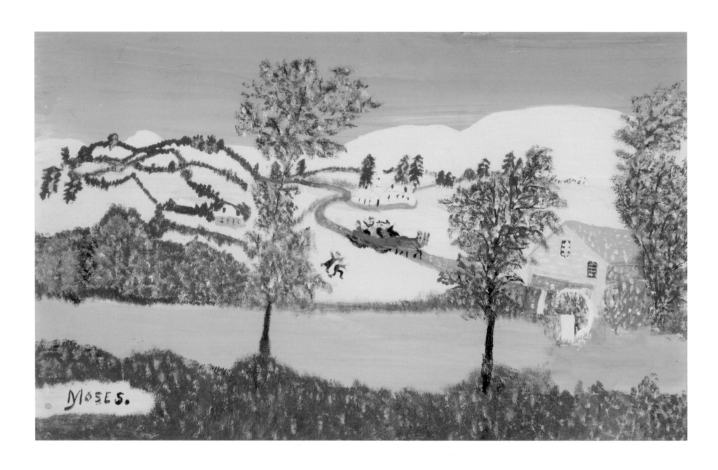

Plate 37

Hurrah, July 8, 1959

Oil and watercolor, 8 x 12 ⁷/₈ inches · **K1392**

The colorful figures in the center of this painting are very small, but the message and jubilant mood Moses imparts are unmistakable. Note that this enthusiastic winter scene was painted in mid-summer.

Collection of Sandra and Bill Piskuran

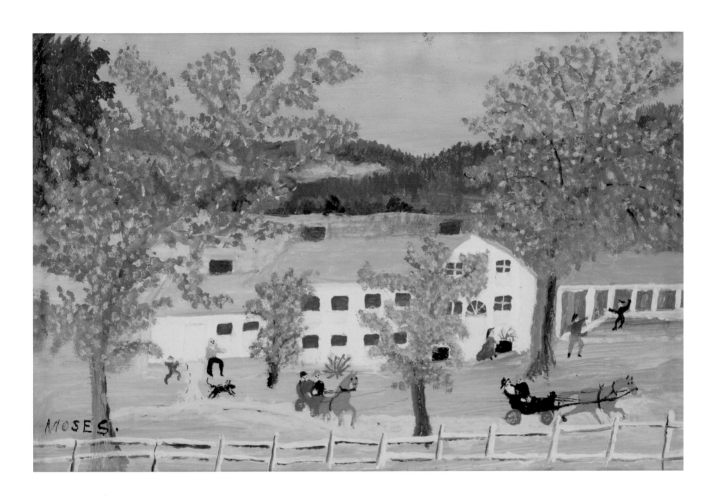

Plate 38

The Old Inn, 1959

Oil on pressed wood, 7 7/8 x 12 inches · **K1421**

Moses frequently painted her environment through the seasons. Her
sense of place is recognized through the vernacular architecture of this
unidentified inn. The white post-and-rail fence in the foreground, the
inn itself, the forested hills in the background, and the gray sky all seem
familiar, as do the autumn leaves dancing in their burnished red and
yellow finery.

The inn might have existed in upstate New York, a region with which
Moses was intimately familiar and where she lived most of her life.

Collection of the Bennington Museum, Bennington, Vermont

Plate 39

One Horse Sleigh, 1959

Oil and glitter on pressed wood, 16 x 24 inches · **K1443**

The title of this painting may have been inspired by the popular Christmas song "Jingle Bells," which was written in 1857 by James Pierpont, originally for a Thanksgiving program at his church in Boston. In the lower foreground two people snuggled under a blanket are "dashing through the snow in a one-horse open sleigh." Instead of the hardships and inconveniences of winter, the artist turns to the season's beauty: a white snowy carpet on the ground, silvery trees amidst scattered gable-roofed houses, evergreens, and a soft pink-and-blue sky in the background. The textured white brushstrokes of the trees contrast with the smoothness of the white ground.

Collection of the Bennington Museum, Bennington, Vermont

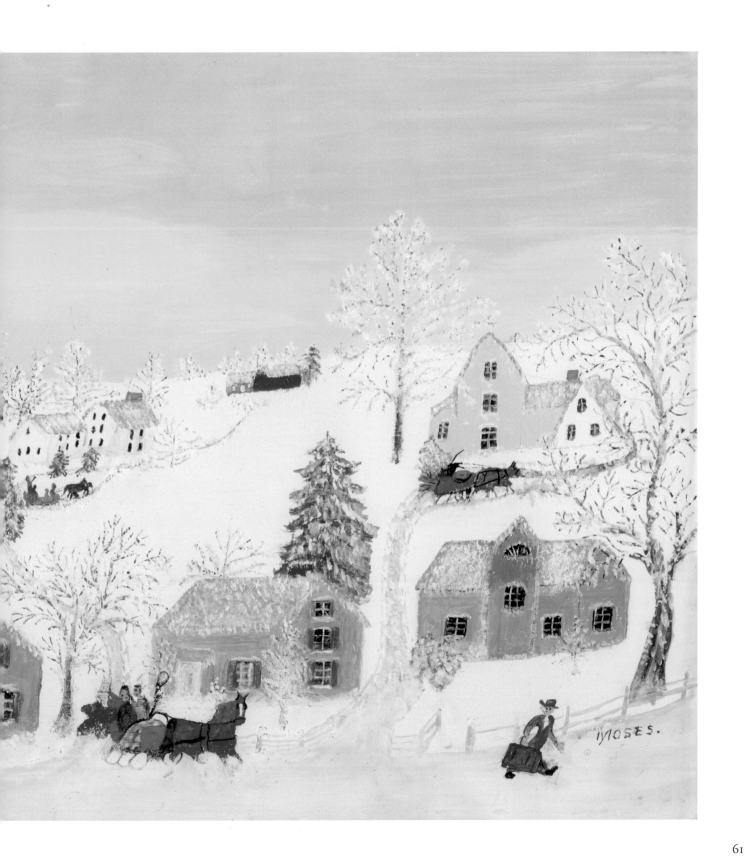

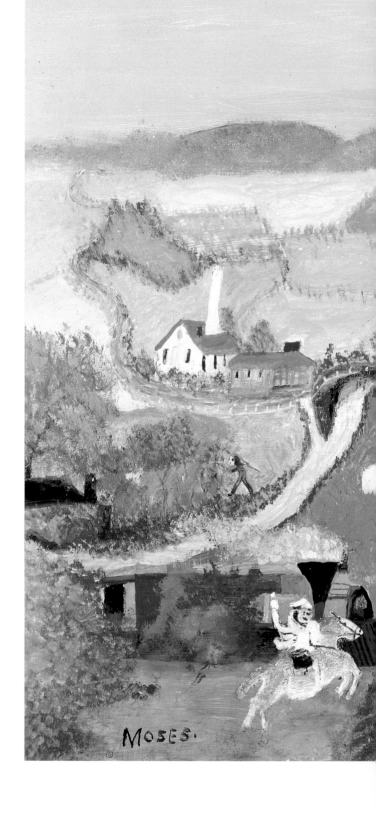

Plate 40

Horseshoeing, 1960

Oil on pressed wood, 16 x 24 inches · **K1471**

The blacksmith was an important artisan in every early American town, providing essential services for farmers and tradesmen. Those who shod horses were also know as farriers.

Even near the end of her life, Moses continued to be inventive. Here she used the cutaway device to simultaneously show the inside and outside of the blacksmith shop.

Collection of Harry L. & Roy W. Moses; photograph courtesy of The Galerie
St. Etienne, New York

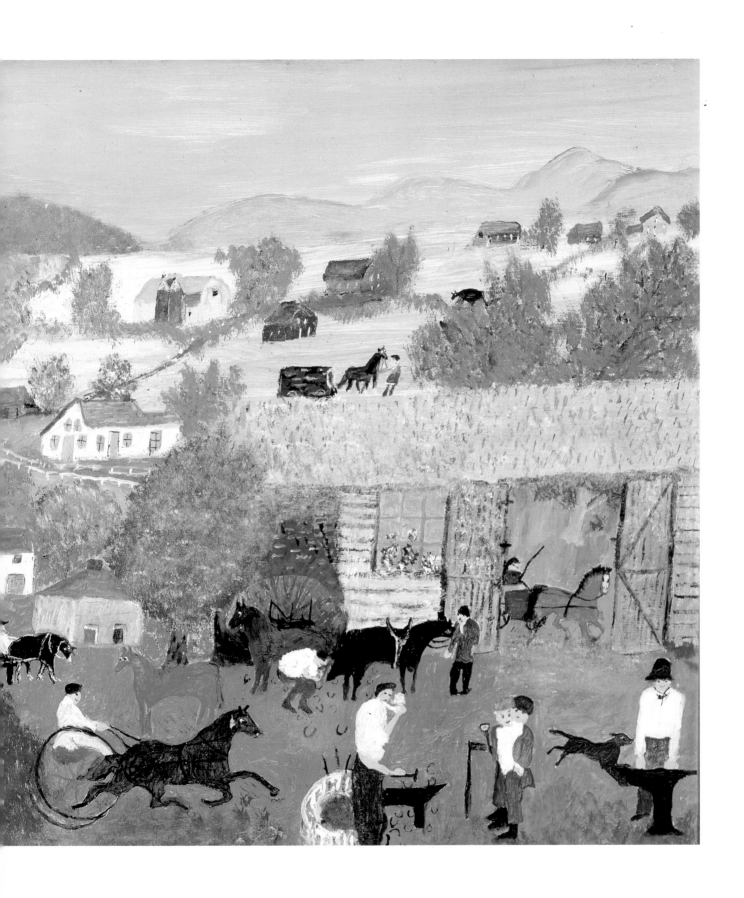

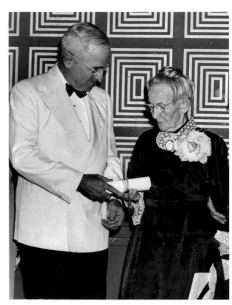

Grandma Moses receiving the Women's National Press Club Award from
President Harry S. Truman, May 14, 1949

Catalogue editor: Paul S. D'Ambrosio, Ph.D.

Exhibition script: Lee Kogan

Exhibition management: Michelle Murdock, Kathleen D. Stocking

Design and composition by John Bernstein Design, Inc., Brooklyn, N.Y.

Catalogue production by Robert L. Freudenheim, Buffalo, N.Y.

Manufacturing by United Graphics, Buffalo, N.Y.

Primary photography by Richard Walker (plates 1, 2, 3, 6, 7, 10, 11, 12, 13, 15, 17, 20, 21, 22, 23,
24, 26, 27, 30, 31, 32, 33, 35, 37, 38, 39); Other photographs by Geoffrey Clements, New York
(plate 8), John Parnell, New York (plate 18), Eric Pollitzer, New York (plate 29)

The text of this book is composed in FF Scala & FF Scala Sans (FontShop International)

Text copyright © 2007 by Fenimore Art Museum

All illustrations and archival photographs copyright © 2006, Grandma Moses Properties Co., New York

Front cover detail: "The Old Oaken Bucket," 1943 (see plate 7)

Back cover: Moses painting at a table (Bennington Museum, Bennington, Vermont)

Inside covers: Photographs by Richard Walker

Frontispiece: Grandma Moses and Carolyn Thomas at Gimbel's Auditorium, November 14, 1940.

ISBN: 0-917334-33-7